IMAGES
of America

NEWHALL

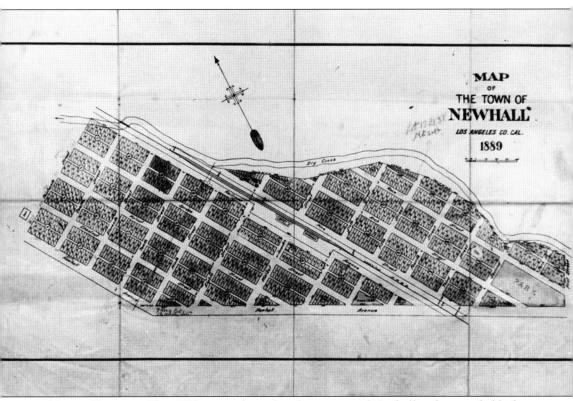

MAP OF NEWHALL. This 1889 map is the earliest known one of Newhall and was probably drawn up for the Newhall Land and Farming Company to show the location of parcels to potential buyers. The railroad is shown, as are the depot and warehouse. The footprint of the Southern Hotel is also shown, so this map must have been drawn before the fire that destroyed it in 1888. (Courtesy of the author's collection.)

ON THE COVER: Newhall has always celebrated the Fourth of July with gusto. An addition to the festivities in the 1930s was the homecoming celebration, inviting former residents to come back for a visit and see all the improvements. A popular contest gave a cash prize to the oldest photograph of Newhall entered. A good time was had by all. (Courtesy of the author's collection.)

IMAGES
of America

NEWHALL

To Jimmy —
Hope you enjoy
the memories!

Maggi Perkins

ARCADIA
PUBLISHING

ISBN 978-0-7385-8025-8

Published by Arcadia Publishing
Charleston SC, Chicago IL, Portsmouth NH, San Francisco CA

Printed in the United States of America

Library of Congress Control Number: 2009935198

For all general information contact Arcadia Publishing at:
Telephone 843-853-2070
Fax 843-853-0044
E-mail sales@arcadiapublishing.com
For customer service and orders:
Toll-Free 1-888-313-2665

Visit us on the Internet at www.arcadiapublishing.com

*To my grandfather Arthur B. Perkins for giving me a love
of history and the sense of humor needed to pursue it*

CONTENTS

ACKNOWLEDGMENTS

The Santa Clarita Valley Historical Society's collections, particularly the scrapbooks, have been a wonderful resource and director Pat Saletore an invaluable collaborator, especially in locating images to fill in the gaps left by my grandfather. Thanks also to my father, Richard Perkins, for preserving his father's work until I was able to take it up.

I also have to thank my editor at Arcadia Publishing, Jerry Roberts, for his prompt responses and for knowing when to push and, more importantly, when not to. A lot of people contribute to writing a book, and most of them never get the thanks they deserve because it would double the length of the book. So I thank you all.

Unless otherwise noted, images are from the author's collection. Additional images primarily appear courtesy of the Santa Clarita Valley Historical Society (SCVHS.)

INTRODUCTION

This book tells the story of Newhall, a town that today is part of the city of Santa Clarita. Why publish a book on part of the city? Because the town came first, and in spite of obstacles and tragedies, it survived and grew, providing the roots from whence the city would grow.

Newhall's story begins long before the name when the Chumash and Tataviam Indian tribes made the valley their home. It was a pleasant place then, with ample water and food, allowing for a peaceful lifestyle. Not much is known about the earliest residents, but artifacts still turn up deep in the canyons, reminding us that they were here first.

Recorded history of the valley begins with the Portola or Sacred Expedition that started in Mexico and made its way north in search of an overland route to Monterey Bay. Fr. Junipero Serra was part of the group of soldiers and padres who braved the unknown, although he chose to stay in San Diego and oversee his new mission and the colony there. Fr. Juan Crespi was his surrogate, and it is from his journal that the first glimpses of the valley are seen through his eyes. In 1769, he declared the valley to be a very pleasant place with friendly Native Americans, and he believed that a mission should be built here in the place he named Santa Clara after St. Clare.

His superiors agreed at first, but when more careful studies were made, the mountains between what would be called the San Fernando and Santa Clarita Valleys were deemed too difficult for regular travel. The mission was built in San Fernando close to the mountains and the trail over them, but it was the land they wanted. It was granted to them as part of the vast holdings most missions had to support themselves and spread their ways among the Native Americans.

Still, the land was isolated and hard to reach, so the mission neglected it—until a lawsuit reminded them that land unused was land that could be taken. A granary was soon built near present-day Castaic Junction. Never a large or important establishment, it barely appears in the mission's records, leading to debate as to its size and nature, and whether it was an asistencia or a smaller, less important estancia. Originally believed to be the larger, most today consign it to the status of a smaller establishment. Either way, it is the valley's only tangible connection to the mission era in California.

When the missions were secularized by Mexico, most of the valley was granted to Antonio del Valle, a former soldier and mission official who knew the land well. The lands were named Rancho San Francisco, and he built his home near the old mission estancia. His holdings were divided after his death in 1841, and his son Ygnacio inherited the land where Newhall would be. Ygnacio built his home farther west than his father and called it Camulos.

The transition from Mexican to American rule was not as easy as the transition from Spanish to Mexican rule had been, in part because of the very different cultures. Titles to land and questions of ownership made life difficult for many of the dons who were used to a more casual, traditional way of life. The hardheaded Yankee businessmen flocking to California outmatched many of them, and many ranchos were sold, in whole or in part, to pay debts incurred under

the new tax laws. Rancho San Francisco was one of the casualties, although Don Ygnacio was able to maintain several hundred acres around his home.

In 1875, a businessman from San Francisco with a keen interest in the railroad and ambition to spare bought most of the Rancho San Francisco at an auction held on the steps of the Los Angeles City Hall. Almost immediately, he negotiated with the young Southern Pacific Railroad, selling it a right-of-way for a token price. Like the city fathers of Los Angeles, he knew the way to future prosperity and growth lay in the railroad and the goods it carried. Los Angeles had already decided to subsidize the boring of a tunnel through the mountains in order to convince the railroad that the best route for the line being built to San Francisco would be through Los Angeles, not San Bernardino. The Southern Pacific Railroad took the money and bored the tunnel—which cost far more than the subsidy. But the route was good, stretching across the Little Santa Clara Valley (to distinguish it from another Santa Clara, near San Francisco) and through the Soledad into California's central valley. In time, a spur line was built to Ventura and was itself extended to San Francisco.

In 1876, with a track in place, the town of Newhall was first laid out. It consisted of little more than the train depot, a store, and a handful of other buildings. After two dry years, there was not much growth, and the entire town moved about 3 miles south, closer to a reliable water source. The buildings moved too, and Newhall reached its permanent home.

Since then, the town has survived the tragic death of its founder and guardian angel, Henry Mayo Newhall, in a riding accident on his Newhall ranch in 1882, repeated economic hard times, the tragic night the St. Francis Dam burst, and many fires and earthquakes. It has not always prospered, but it has always survived.

It is people that make a town, and the early settlers were a tough, stubborn, creative lot. They scratched a living from the ground, whether it was from gold, oil, water, or crops. They built homes and businesses—and rebuilt them after the fires. In between, they did what they could to make their town a community, building schools, churches, and dance halls, and making the Fourth of July a special day every year, with food, games, and fun. That is what it took to live in Newhall—stubbornness, the ability to improvise, and a sense of humor that thrived under harsh conditions.

This book is a celebration of the people of the Newhall and the history they created with hard work and a twinkle in their eyes. It is a trip down memory lane to discover what happened in Newhall.

One

RANCHO SAN FRANCISCO

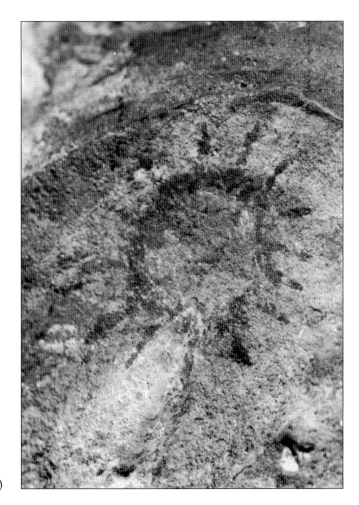

TATAVIAM ROCK PAINTING. The earliest known residents of the Santa Clarita Valley were likely members of the Tataviam Indian tribe, who spoke a dialect of Serrano, one of the Southern California Uto-Aztecan languages. Their settlements were scattered around the valley and surrounding canyons, where some of their rock paintings can still be found. (Courtesy of SCVHS.)

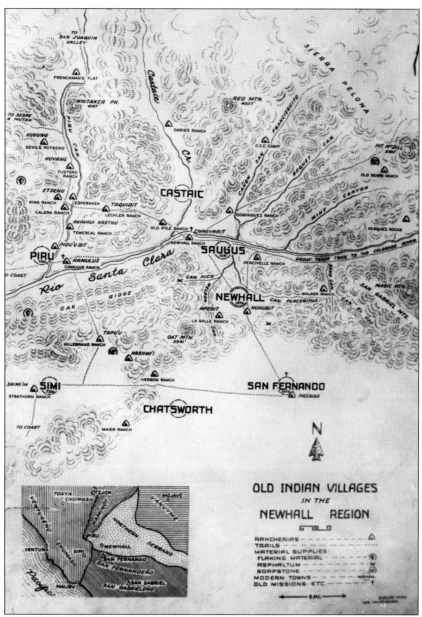

MAP OF TATAVIAM VILLAGES. H. Allen drew this map in 1937, showing the locations of villages throughout the Little Santa Clara Valley (today called Santa Clarita to distinguish it from Santa Clara in Northern California). It is based on the research of Richard F. Van Valkenburg in the 1930s. Van Valkenburg was a painstaking researcher, using the records of Mission San Fernando, interviews, and fieldwork to gather the information shown. With the exception of Castaic, all the names on the map are post-1750. No one is certain of the age of the Castaic name; its related name, Chaguayabit, appears to be even older. Later scholarship has cast serious doubt on the details of this map, particularly the number and location of the villages and the names given. It seems that Van Valkenburg was a better scholar than he was a cartographer and misinterpreted some of the information he gathered. Even so, it represents a fair idea of Native American settlements in the mission era.

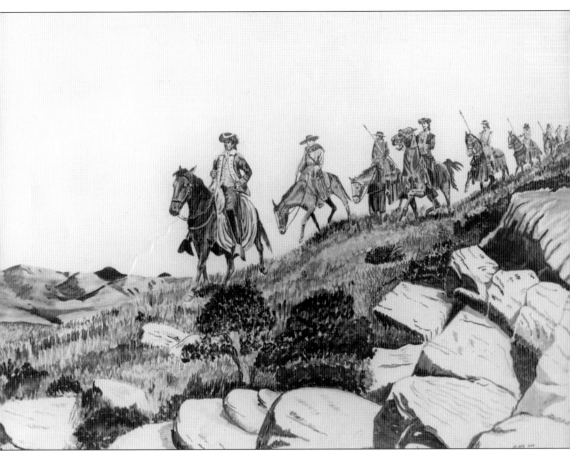

THE SACRED EXPEDITION. Variously called the Sacred Expedition and Portola's Expedition, it was led by Don Gaspar de Portola to search for an overland route to Monterey Bay. Fr. Junipero Serra had come from Mexico with Portola and remained in San Diego at the new colony there, but his men were also on the expedition. On August 8, 1769, they made their way over the mountains to the valley. Fr. Juan Crespi kept a journal and described his first impression of it as a pleasant place with flat ground, two creeks, a river, abundant trees, and lush plants, including grapevines and wild roses. He named the valley for St. Clare and believed that it would be an ideal site for a mission. The expedition took several days to go west across the valley, where they followed the advice of the Native Americans and continued west along the river valley to the coast, avoiding the steep mountain range to the north. (Painting by Jerry Reynolds, courtesy of SCVHS.)

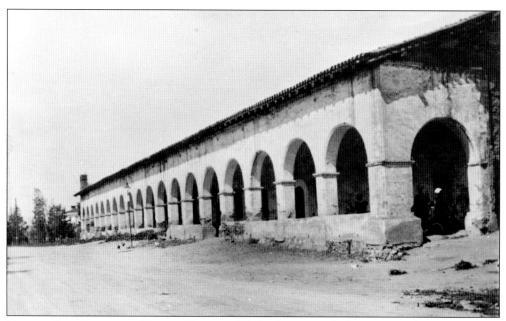

MISSION SAN FERNANDO REY DE ESPANA. While the original plan suggested a mission near present-day Castaic Junction to serve travelers between Mission San Gabriel and Mission San Buenaventura, the difficulties in navigating the mountains separating the San Fernando and Little Santa Clara Valleys resulted in the site being moved to San Fernando. The mission was completed in 1797 and claimed the earlier site as part of its holdings.

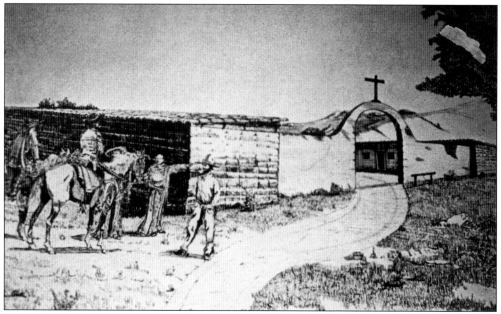

ESTANCIA AT CASTAIC JUNCTION. The entire Little Santa Clara Valley was placed under Mission San Fernando's ownership. In 1804, Francisco Avila attempted to gain control of the lands on the basis of disuse. To protect its far-flung holdings, the asistencia or estancia (opinions differ) was built that same year. Due to nearly nonexistent records, the location and precise nature of the buildings were lost over time. (Painting by Jerry Reynolds; courtesy of SCVHS.)

ESTANCIA DIG. Richard F. Van Valkenburg and Arthur B. Perkins discovered the ruins in 1935 while they were looking for remains of a mission-era dam. Arthur Woodward of the Los Angeles County Museum of Natural History led the subsequent dig, and workers included the entire Perkins family, right down to five-year-old Richard Perkins (shown here with his father, Arthur B. Perkins.)

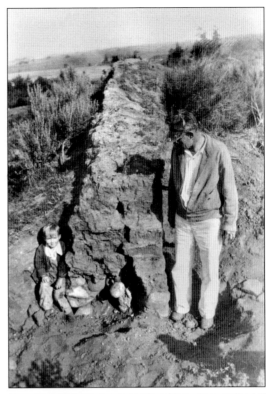

TILE FLOOR OF ESTANCIA. The dig uncovered traces of two buildings, with surviving walls up to 4 feet high and this tile floor. Dreams of a full restoration were dashed in 1936 when vandals smashed the floor and undermined the walls while looking for an imaginary mission treasure. A visit to the site in 1946 led to the sad discovery that the entire site had been bulldozed, and no traces remained.

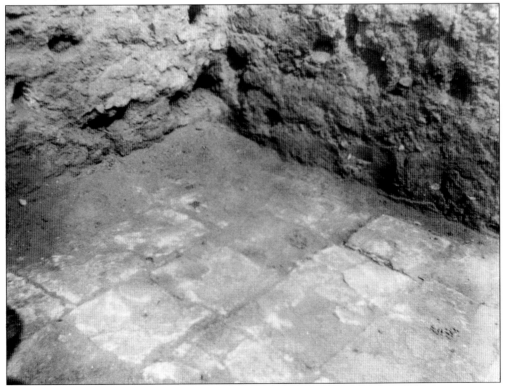

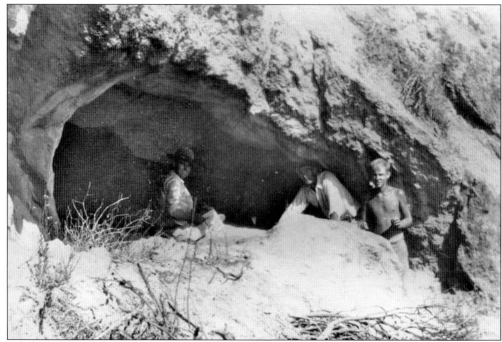

ENTRANCE OF BOWERS CAVE. Discovered in 1884 by McCoy Pyle and his brother Everett, the cave held a treasure trove of Native American artifacts. They sold the lot to Dr. Stephen Bowers of Ventura for $15 (or $1,500—accounts vary). Bowers then sold most of the collection to Yale University's Peabody Museum. This photograph shows (from left to right) Richard F. Van Valkenburg, Arthur B. Perkins, and his son Arthur Jr. on a later exploration.

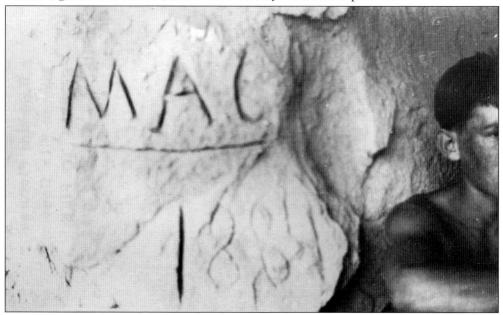

GRAFFITI, BOWERS CAVE. As is so often the case, not much is known about the actual founders of the cave, but young McCoy Pyle left his name and the date on the cave wall—almost as if he knew his name would not be associated with their find in the future.

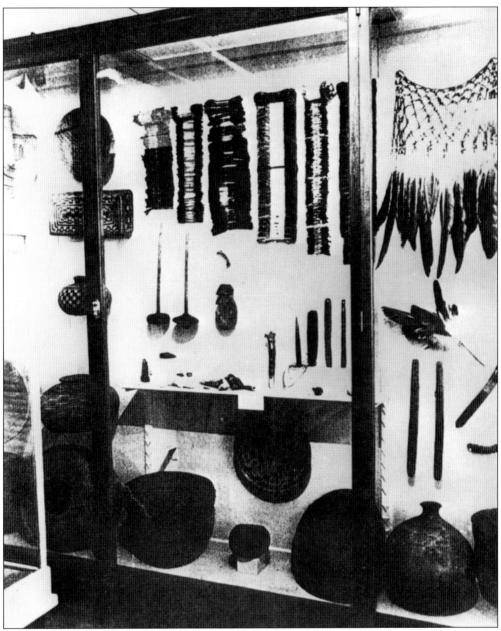

BOWERS CAVE ARTIFACTS. The boys found a storage cave used by the Native Americans of the mission period. Generally, such caves were used to store food and goods rather than as residences. The cache included more than 35 items, including rare feather-work artifacts, many baskets of varying sizes and purposes, bone whistles or flutes, and other objects made of bone, wood, and stone. One of the most interesting objects was a set of four doughnut-shaped stones mounted on wooden handles. The stones had been seen before but not mounted. Researchers speculate that they were ceremonial staffs or perhaps sun sticks used as a sort of calendar device to determine the season. The nature of the artifacts found makes it likely that much of the cache was ceremonial regalia carefully concealed from the mission fathers who would have destroyed them as dangerous heathen objects. (Photograph by Ted Lamkin, courtesy of SCVHS.)

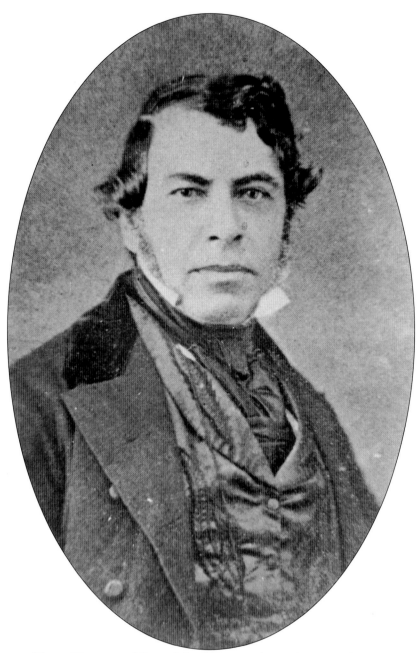

YGNACIO DEL VALLE. The original Spanish land grant to the Little Santa Clara Valley (so called to differentiate it from the Santa Clara Valley in Northern California) called it Rancho San Francisco, and it went to Antonio del Valle when the missions were secularized in 1839 under Mexican rule. Del Valle died in 1841 and his eldest son, Ygnacio, and his widow, Jacoba Feliz, divided the land after a protracted legal battle. Active in Los Angeles politics, Ygnacio lived in the city, serving variously on the junta (city council) in the 1840s, as treasurer for Gov. Pio Pico, as alcade, and then after statehood, he was a member of the California State Assembly and Los Angeles City Council for five years, ending in 1857. After that, he focused his attention on improving his lands and moved to Rancho Camulos with his family in 1861.

CAMULOS RANCH HOUSE. As his family grew, the original adobe built by Ygnacio was expanded over the years from four rooms to 20, with many outbuildings, including a winery, a chapel, a barn, and housing for the rancho's workers. The rancho also grew from a few hundred cattle to a bustling farm with vineyards, orchards, and grain growing, supporting nearly 200 people.

FIESTA AT CAMULOS. The del Valles carried on the Californio tradition of lavish hospitality to the delight of travelers and to the detriment of the family finances. By the 1920s, only around 1,800 acres remained of the original 48,612-acre grant. In 1924, the family sold Rancho Camulos to August Rubel. Today Camulos is a national historic landmark and is open to the public, a rare survival of the rancho period.

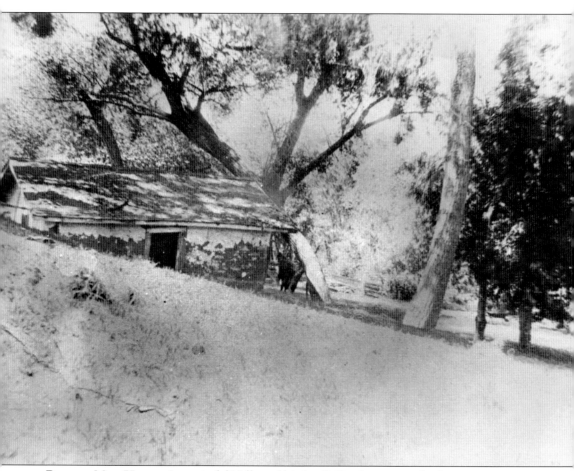

RANCHO MILK HOUSE. Antonio del Valle and his family lived at or near the former asistencia on the eastern side of Rancho San Francisco (near present-day Castaic Junction). The milk house was built in the 1840s, as one of the rancho's outbuildings. In February 1850, men from the rancho came across a band of starving, desperate travelers in the mountains and took them back to the rancho. They were survivors of the Manley or Jayhawker party, which had lost its way on the journey from Salt Lake City to Los Angeles. They thought they could find their way without a guide, but like so many before and after them, they were wrong. The expedition's ill fate gave Death Valley its name. The survivors stayed about two weeks at the rancho before continuing onto Los Angeles and disappearing into history. They did hold reunions into the early 1900s and expressed hope that the milk house they so fondly remembered would be preserved as a landmark. That did not happen, and the exposed adobe basically melted under heavy rain in the 1930s.

FRANCISCO LOPEZ. Jose Francisco de Gracia Lopez was an uncle of Don Antonio del Valle's second wife, Jacoba Feliz. No ignorant vaquero, he studied mineralogy at the university in Mexico and knew how to search for gold. He may have also known local stories of gold being found in the valley as early as 1820. Nonetheless, his position as the first documented finder of gold in California remains secure. (Courtesy of SCVHS.)

THE OAK OF THE GOLDEN DREAM. In 1842, Francisco Lopez discovered gold in Placerita Canyon. The story goes that he was hunting for stray cattle, took a midday nap, and dreamed of gold. When he woke up and gathered some wild onions, he found gold clinging to the roots. Some dispute the romantic details and the precise tree, but no one denies that Lopez found gold that day.

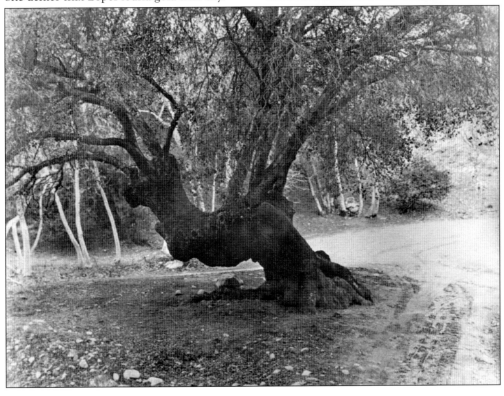

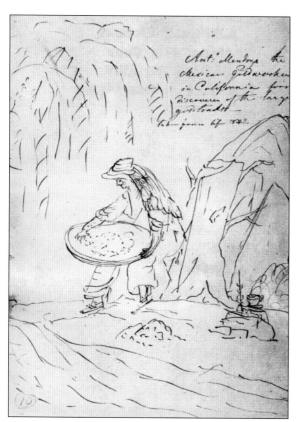

PANNING FOR GOLD, 1842. Word of the find spread quickly, and miners came to make their fortunes. As John Sutter was to find out a few years later, gold fever is no respecter of property. Within two months of the find, the del Valles went to the law and established the first mining district laws in California.

GOLD WASHING, 1842. The first miners mostly came from Sonora, Mexico, and the low-tech mining techniques they used were well suited to Placerita, where they would pan and placer to find gold. Both relied on water and gravity, whether with a simple pan or a more complicated rocker that washed the gold down a wooden chute.

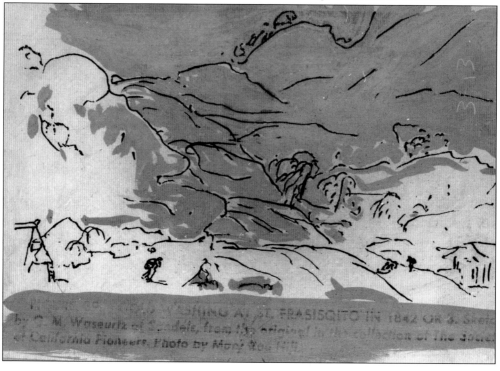

MINERS CAMP. The easy pickings in Placerita Canyon had largely played out by 1849, but there was still gold left for the patient miner. As the gold was mostly placer (hence the name Placerita), large-scale operations and heavy machinery were not as cost effective as they would be in the nearby Soledad or in the Northern California gold rush that was just beginning. Here miners worked their claims in relative quiet, watching for the flecks of gold in their pans or rockers. When the railroad tunnel was finished in 1875, several Chinese workers decided to stay and try their luck. No one got rich, but most of them made enough to get along—and if they did not, they packed up and moved north to the Soledad or even farther. Some might have decided that gold was not the way to make a fortune after all.

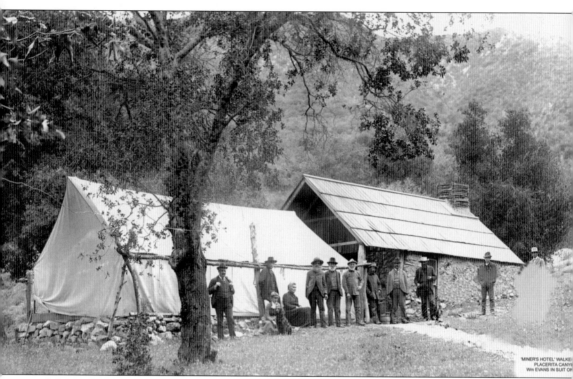

MINERS HOTEL, PLACERITA CANYON. Some of the miners who continued to work in Placerita Canyon in the later 1800s were part-timers, coming out to pan for gold on days off or when they needed some extra cash. Since they did not maintain campsites or want to commute all the way up the canyon, a hotel of sorts was opened to accommodate them. Amenities were likely scarce, but it was a place to sleep and probably to get something to eat. As Los Angeles grew more civilized, people began wanting to get away into the country. Some were returning to old haunts, and others were having relatively safe adventures in the country. However, all appreciated the quiet, the scenery, and the fresh air. This photograph shows what appears to be a large family group on an outing. The older lady has the typical strong features of a Californio, and the younger lady is very well dressed for her outing. (Courtesy of SCVHS.)

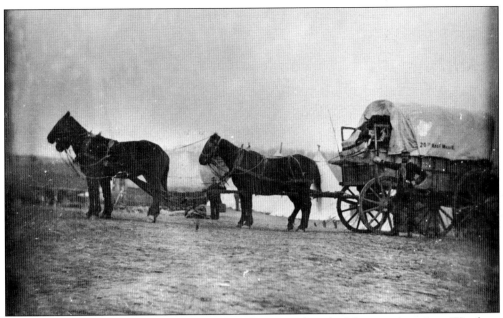

THE MORMON BATTALION. The Mormon Battalion served in the Mexican-American War from July 1846 to July 1847. They marched from Iowa to San Diego and performed occupation duties there until their discharge in Los Angeles. They are credited with opening wagon routes around the Los Angeles and San Bernardino areas as they made their way home. This photograph shows a contingent near the pass that would later become Beale's Cut.

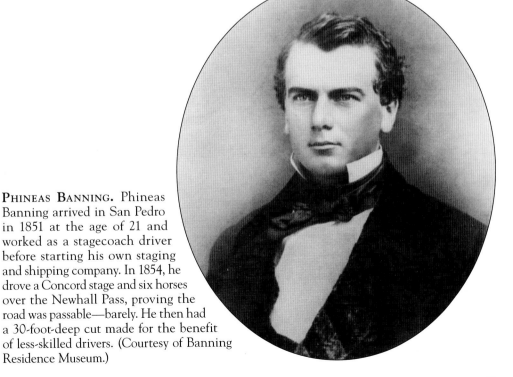

PHINEAS BANNING. Phineas Banning arrived in San Pedro in 1851 at the age of 21 and worked as a stagecoach driver before starting his own staging and shipping company. In 1854, he drove a Concord stage and six horses over the Newhall Pass, proving the road was passable—barely. He then had a 30-foot-deep cut made for the benefit of less-skilled drivers. (Courtesy of Banning Residence Museum.)

EDWARD FITZGERALD BEALE. Before Edward Fitzgerald Beale laid eyes on Phineas Banning's cut around 1863, he had already lived enough for several men. Born in 1822, he graduated from the Philadelphia Naval School in 1842 and served in the U.S. Navy until 1851. During that time, he crossed the United States eight times in the line of duty, including a top-secret journey made in disguise to bring the government proof of the discovery of gold in 1848. After leaving the navy, he returned to California to work as a property manager before taking up no fewer than three separate appointments under three successive presidents. He acquired the toll road franchise in 1863 and set about deepening the 30-foot-deep cut to 90 feet. The massive undertaking was deemed necessary by the city fathers of Los Angeles, who were always looking for ways to improve the flow of goods in and out of Southern California.

BEALE'S CUT, 1872. This early view of the north side of the cut shows a wagon and a lone man, apparently contemplating the steep road ahead. Even at 90 feet deep, the ascent and descent were dangerously steep, often requiring extra horses or log drags for safety. Stage passengers generally got out and walked, preferring to rejoin the driver on more level ground.

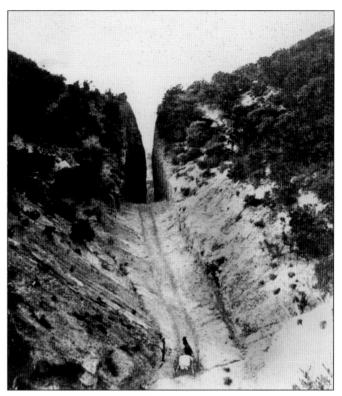

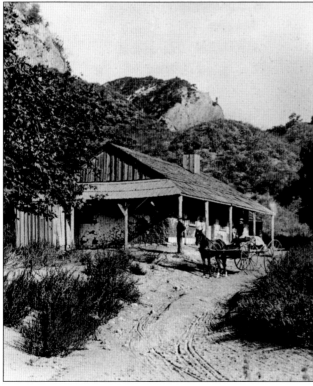

TOLLHOUSE AT BEALE'S CUT. Sited on the south side of the cut, not many got by the vigilant keepers. Tolls ranged from $2 for a jerk line team down to 3¢ a head for sheep. Opened in 1863, it stayed in business until 1887, by which time the railroad had taken most of the lucrative hauling business away.

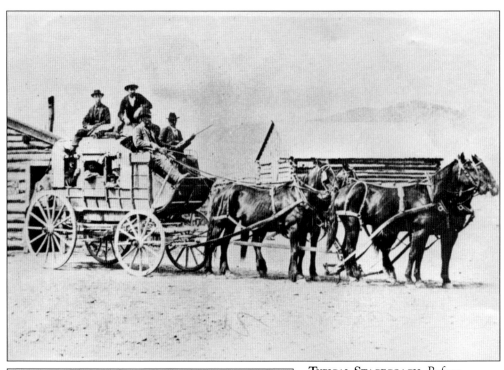

TYPICAL STAGECOACH. Before the railroad came through, the stagecoach was not only the primary means of travel and mail delivery, but it also carried the news of the day. The drivers were personalities, gathering and distributing news and gossip along their routes. The price of beef and wheat, marriages, births, deaths, dances, and warning of bandits all flowed through the stagecoach driver, keeping people on far-flung ranches connected and informed.

SANFORD LYON. Sanford Lyon and his brother Cyrus arrived in Los Angeles in 1849 and began working as clerks. They opened Lyon Station in 1854 to serve the increasing stagecoach traffic through Banning's, and later Beale's, cut. Lyon also dabbled in oil and mining, but not much seems to have come of either. He died in 1882 and was buried at the Lyon Station Cemetery.

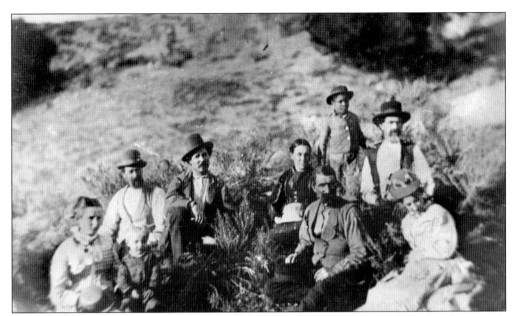

The Lyon Station Gang. No photograph of Lyon Station is known, but this photograph from about 1875 is identified as the "Lyon Station Gang." Only the little black boy's name was noted—Ashbridge. The precise location of Lyon Station is debated, but the historic landmark marker can be found at Eternal Valley Cemetery.

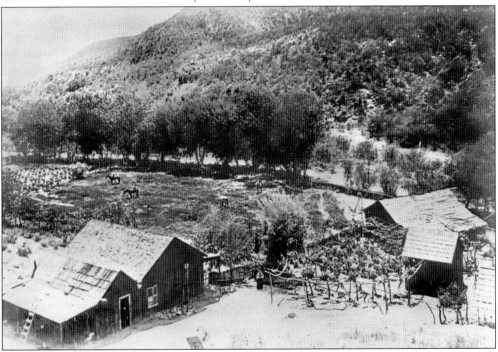

King's Stage Station. This station, once located at the other end of the Santa Clarita Valley, was probably similar to Lyon Station in basic construction. The actual adobe station building is on the right. Later the Raggio family used it as a winery. Located less than a mile from the St. Francis Dam, everything in this photograph was washed away by the dam collapse in 1928.

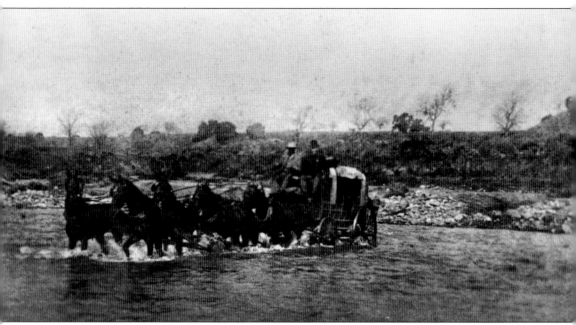

STAGE FORDING SANTA CLARA RIVER. Because the town of Newhall is nearer to the dramatic San Gabriel Mountains traversed by the engineering marvels of Beale's Cut and the Newhall railroad tunnel, there is a tendency to forget that travel in and out of the west side of the Little Santa Clara Valley was also challenging in the early days before modern roads and bridges. Also forgotten is that the Santa Clara River used to have much more water flowing much deeper and faster aboveground, unlike today, where the visible water is barely a trickle until the rains come. This very old photograph is believed to show the Ventura-Newhall Stage carefully fording the Santa Clara River sometime between 1876 and 1887. It was probably taken near Castaic Junction and is one of the few photographs of a stagecoach in action in the valley.

Two

NEWHALL'S EARLY DAYS

RECEIPT, SAN FRANCISCO AND SAN JOSE RAILROAD. Henry Mayo Newhall wanted to extend his local success with railroads across the continent, but the Big Four repeatedly outmaneuvered or blocked his plans. Eventually he sold out to the Southern Pacific Railroad. As a mark of respect for a formidable opponent, the board of directors accepted him as a member, and he held the position for the rest of his life.

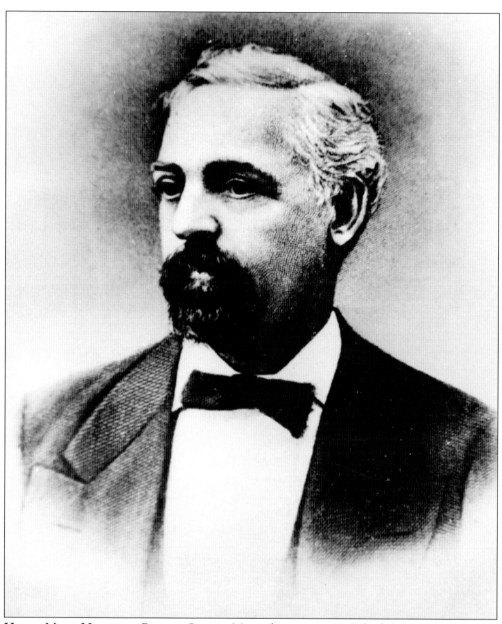

HENRY MAYO NEWHALL. Born in Saugus, Massachusetts, in 1825, he left his position as an auctioneer in 1849 to join the California gold rush. Arriving in San Francisco in 1850, he felt he had missed his opportunity to strike it rich in the gold fields and instead stayed in San Francisco, using his auctioneering skills to build a thriving business, H. M. Newhall and Company. He began investing in railroads, eventually becoming a director of the newly formed Southern Pacific Railroad. He felt the more than 40,000 acres of Rancho San Francisco he had purchased in 1875 held great promise and granted a right-of-way to the Southern Pacific Railroad, ensuring the new Los Angeles–to–San Francisco line would cross his land. The new town was named Newhall by the railroad, and it began to grow, but he did not live to see it thrive, dying in 1882 after a fall from his horse. The town lost momentum after his death, stabilizing after his heirs formed the Newhall Land and Farming Company to manage and preserve their inheritance.

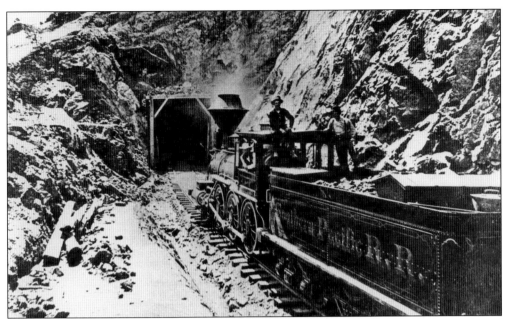

NEWHALL RAILROAD TUNNEL. Knowing the railroad was vital to the continued growth and prosperity of the area, the Los Angeles city fathers voted to subsidize part of the construction costs to tunnel through the San Fernando Pass. After nearly 18 months of digging, the tunnel was completed in 1876. As it turned out, the difficult geology of the terrain meant that the Southern Pacific Railroad spent far more than they had been given.

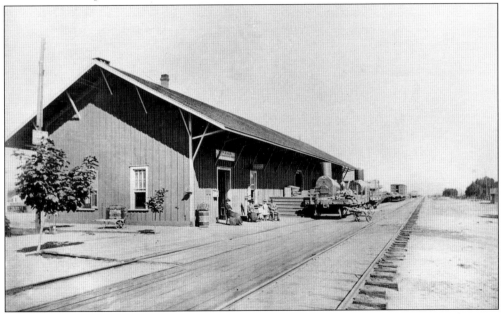

NEWHALL TRAIN DEPOT, C. 1881. The Newhall train depot was built in the summer of 1876 at the original town site. Adverse conditions led to the entire town picking up and moving, buildings included, about 3 miles south in January 1878. The two flat cars in the photograph are carrying donkey boilers destined for the Pico oil fields. A careful look at the doorway reveals a fashionable young lady patiently waiting for her train.

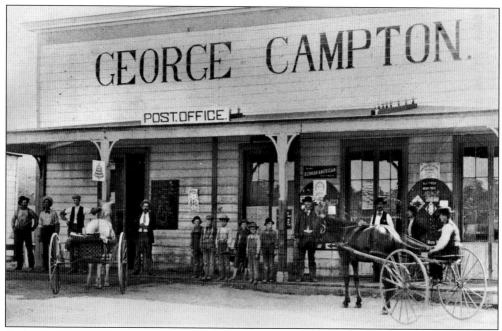

CAMPTON'S FIRST STORE. George Campton opened his first general store at Newhall's original town site and then moved his business and building along with the rest of the town in 1878. The new location was across the street from the train depot on what became Railroad Avenue. The store burned down shortly after this picture was taken in 1878.

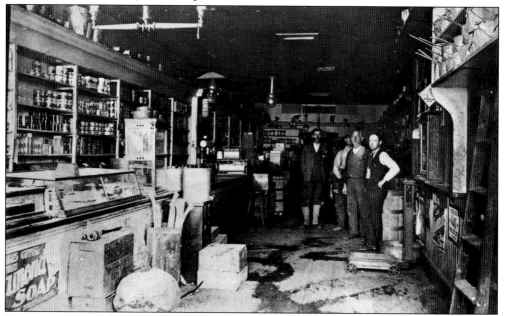

INTERIOR OF CAMPTON'S STORE, C. 1908. Pictured from left to right are two unidentified men, George Campton, and Frank Landell. Campton was Newhall's first postmaster, and Landell kept the books, later becoming postmaster himself and running the store in partnership with Nick Lindenfelt. The one important feature of the store not shown is the whiskey barrel. It was in the back room, and access was generally obtained by paying off one's tab.

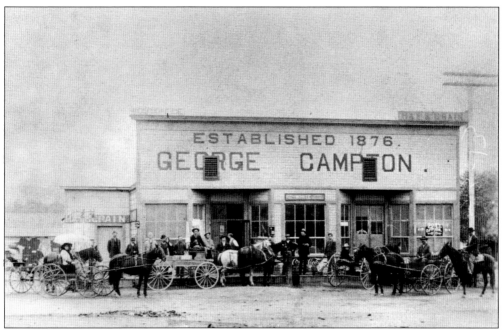

CAMPTON'S SECOND STORE. Within months after the fire that destroyed the original building, Campton rebuilt his general store. The frontage was about the same, and the new look of the store included deep bay windows that revealed business was good, even with the competition of the Newhall Ranch store at the other end of the block. In 1914, new owner Edgar Lewman moved the business to Spruce Street. He did that by simply moving the building back 30 feet so it fronted on Spruce Street. The back of the building was remodeled to be the front of the store, and the front became the back of the store. In later years, the building was moved 30 feet farther from the corner of Spruce and Eighth Streets to allow for the construction of Newhall's first bank.

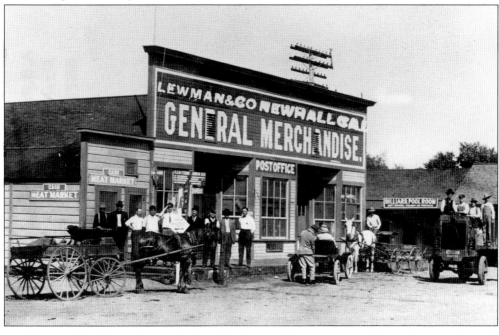

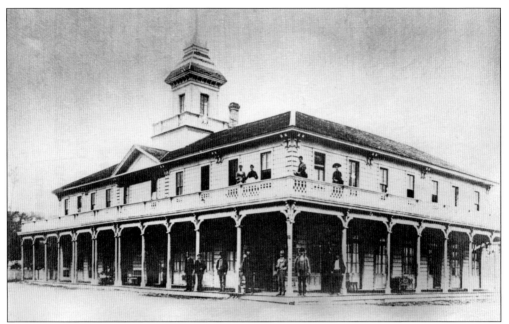

THE FIRST SOUTHERN HOTEL. Built by Henry Mayo Newhall across Railroad Avenue from the train depot, the hotel opened in February 1878 and was hailed as one of the finest hotels in California outside of San Francisco and Los Angeles. The hotel was the social center for the town, with the reading room a particular favorite. However, this elegant structure burned to the ground in October 1888.

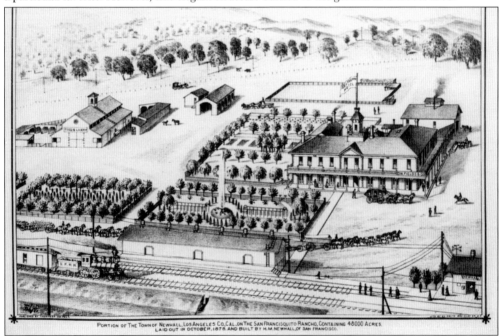

PORTION OF THE TOWN OF NEWHALL, LOS ANGELES CO., CAL., ON THE SAN FRANCISQUITO RANCHO, CONTAINING 48000 ACRES. LAID OUT IN OCTOBER, 1878, AND BUILT BY H.M. NEWHALL, OF SAN FRANCISCO.

ENGRAVING OF THE SOUTHERN HOTEL. This engraving from about 1879 shows the scope of Newhall's ambition for his new town. The Southern Hotel was a multistory Victorian architectural marvel in a town barely two blocks long. Research has shown the engraving is an accurate representation of the hotel's extensive gardens.

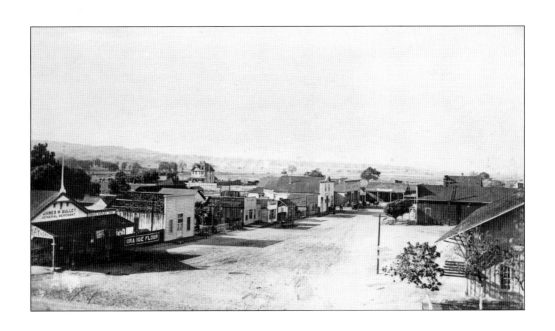

VIEW OF NEWHALL, C. 1896. Most of the town can be seen in this photograph of Railroad Avenue. On the left is the Gulley Store, which started out as the J. O. Newhall Store in the late 1880s and was located across from the Southern Hotel on the northeast corner of Market Street and Railroad Avenue. It went through several hands before the building's destruction around 1930. Next to it is (from left to right) Judge Powell's home, the Rivera Saloon, Powell's Palace Saloon, and Campton's Store. Across Eighth Street to the right of Campton's store is the Derrick Saloon, with the Delano complex behind. Across Railroad Avenue, the Hardison and Stewart warehouse is partially obscured by trees. The depot's shadow can be seen but not the building. The two-story building in the background is the first Newhall schoolhouse.

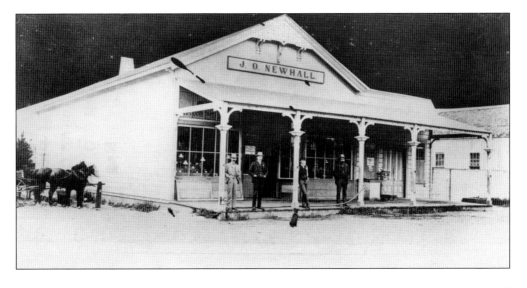

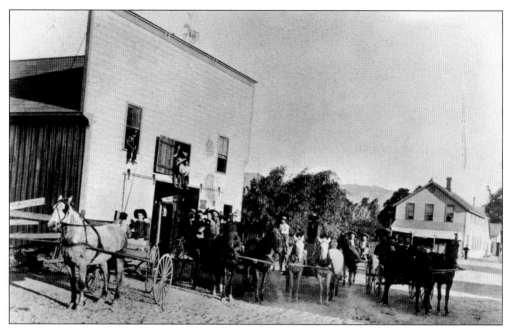

THE SECOND SOUTHERN HOTEL. After the Southern Hotel burned down, the carriage house was remodeled and became the second Southern Hotel. Located behind the original, it can be seen on the left, on the southeast corner of Market and Spruce Streets. Not nearly so elegant, it nonetheless did good business, particularly with the movie crews that were beginning to work in and around Newhall.

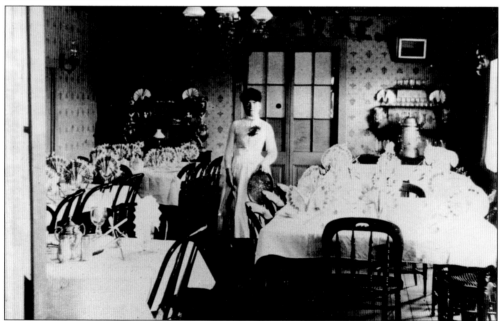

DINING ROOM, SECOND SOUTHERN HOTEL. While not as well appointed as its predecessor, this photograph shows that the interior and furnishings of the second Southern Hotel were of good quality and tastefully done with an eye to details. The lady's sour expression may stem from the effort of pleating so many napkins before the evening meal.

Hardison and Stewart Warehouse. Built in 1883 by Lyman Stewart and Wallace Hardison, they sold the warehouse the next year to the Pacific Coast Oil Company. Later Frances Phillips bought the building and converted it into a restaurant and boardinghouse. It stood (barely) until 1932, when it was torn down, and the lumber was salvaged for a ranch in Wildwood Canyon. When it was built, it included a vault with a big iron door. Over the years, townsfolk sometimes talked the owner into storing their valuables there since Newhall did not have a bank until the 1930s. Everyone believed that the vault would keep their valuables safe from theft or all-too-frequent fires. The salvage team discovered that behind the big iron door was a vault built of a single course of brick with no reinforcement. No one ever suspected, as the vault had never been breached.

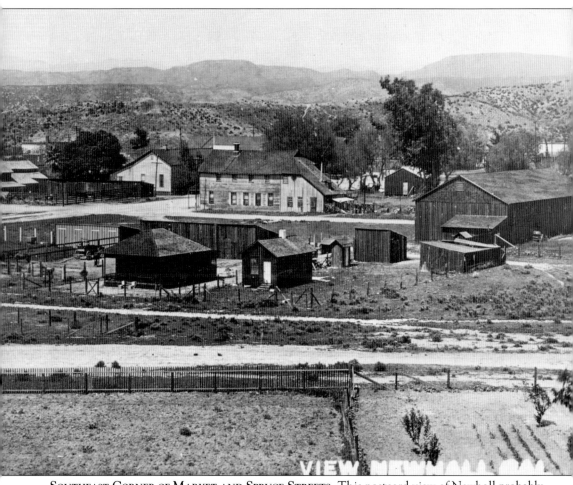

SOUTHEAST CORNER OF MARKET AND SPRUCE STREETS. This postcard view of Newhall probably was taken in the late 1890s when the second Southern Hotel was relatively new. Ed Louden had the bright idea to remodel the destroyed hotel's former carriage house, and he was able to convince Ed Pardee, the town constable, to loan him the money for the job. Louden turned out to be not much of a businessman and was unable to pay when the mortgage came due. So Pardee went into the hotel business. The hotel is the center of attention, but just to its left is the general store on Railroad Avenue, probably still being run by Joshua O. Newhall at the time. On the far left, also on Spruce Street, are the partially visible roofs of the Pardee livery stables. It is hard to believe that the main business street of Newhall was only one block away.

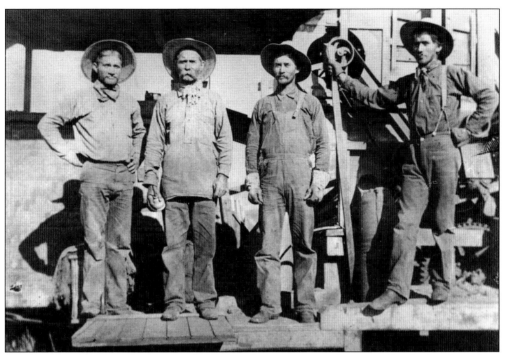

SWALL HARVESTER CREW. Jake Swall and his three sons ran a harvester for the local ranches. His son Albert was ambitious and started his own butcher shop when he was 19. His small store was on Eighth Street next to the Derrick Saloon. He turned out to be a natural businessman and wound up owning much of the business district. From left to right are Albert, Jake, Henry, and ? Swall.

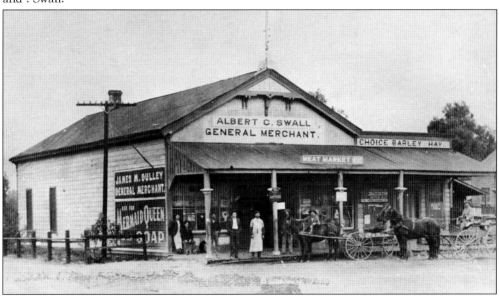

SWALL STORE. Persuaded by his cousin Jim Gulley to move his meat market into his store, Albert soon became sole proprietor. Around 1908, his landlord raised the rent, assuming Albert would have no choice but to pay it. Instead Albert looked a block over and bought the aging second Southern Hotel. He moved the store into the ground floor and continued to rent the top floor rooms to guests.

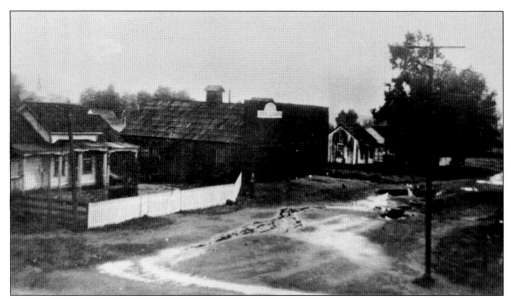

NORTHWEST CORNER OF MARKET AND SPRUCE STREETS. This photograph from about 1898 shows the Frew Blacksmith Shop (center) and the Frew home on the left. The house was built by Adam Malinewski at Lyon Station in 1873 and was moved to Spruce Street around 1878 when it became the home of Joshua O. Newhall. Moved again in the 1920s to Thirteenth Street, the core of the house survives to this day.

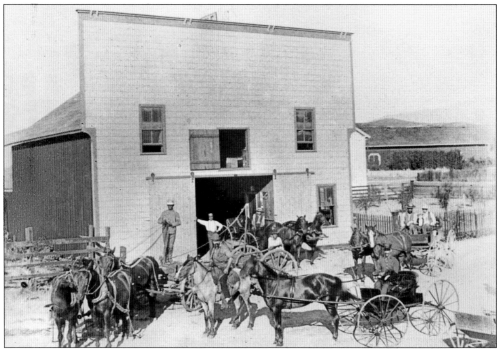

RUSH HOUR AT PARDEE'S LIVERY. A mainstay on Spruce Street, the livery stable was located between Market and Eighth Streets, roughly across from the Frew Blacksmith Shop. Even after the automobile came to Newhall, the horse and wagon were much better suited to the outlying roads of the valley, keeping the town's livery stables open.

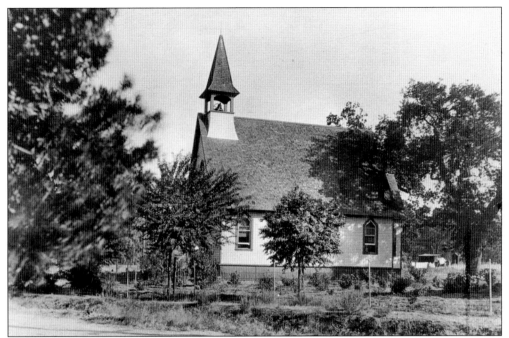

THE FIRST PRESBYTERIAN CHURCH. Newhall had four saloons before it had a church. Before the Presbyterian church was built, services were held at the Southern Hotel and other locations around town. Built in 1891, the church was slightly removed from the downtown, being on the corner of Market Street and Newhall Avenue. When the time came for a larger church, the building was moved a few blocks and became a duplex.

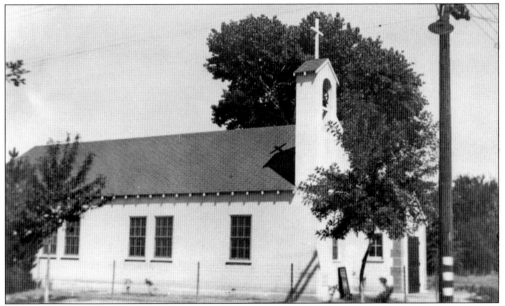

CATHOLIC CHURCH. Newhall's second Catholic church was located at the corner of Tenth and Walnut Streets. The congregation moved to a larger church in 1939 shortly before this photograph was taken in 1940. While similar in appearance to today's Trinity Catholic Church on Newhall Avenue, no evidence exists to suggest that it is the same building in a new location.

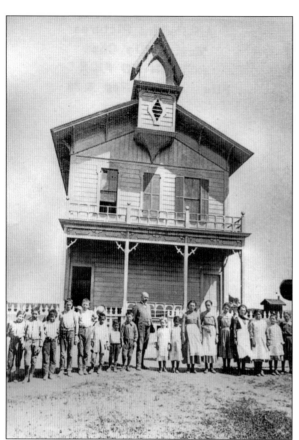

THE FIRST NEWHALL SCHOOLHOUSE. The Newhall school district was organized on May 10, 1876, to serve the tiny population of local students who were then being taught in a bunkhouse on A. W. Lyon's ranch. As part of his campaign to attract a larger population, Henry Mayo Newhall donated the two-story schoolhouse built in 1880 on the northeast corner of Ninth and Walnut Streets.

THE SECOND NEWHALL SCHOOLHOUSE. After the first schoolhouse burned down in 1890, this building was completed in less than a year to serve an expanding, though still small, student population. This time, the project was funded by local leader and prohibitionist Henry Clay Needham. Built near the site of the first school, it was destroyed in an 1894 fire.

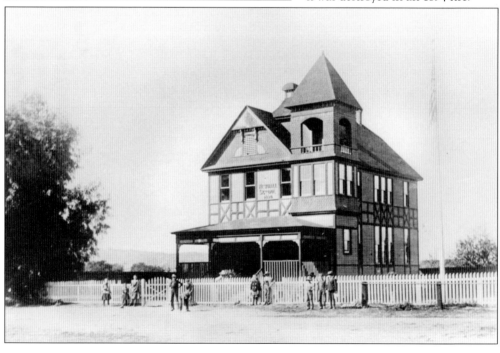

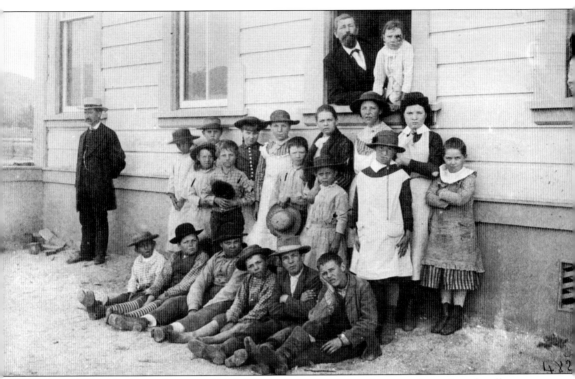

STUDENTS AT NEWHALL SCHOOL, 1884. While the parents were happy to have the schoolhouse built near town and regular classes being taught, one suspects the local children may well have preferred the more casual schooling of the past. Taken at the side of the first schoolhouse, this picture shows virtually the entire student body and their teachers. In the windows are J. W. Myers and Flora Morrison, with Matilda Duran on her own. From left to right are (first row) Romulo Campton, Frank Hardison, Seth Hardison, ? Greminger, Dave Greminger, and Clarence Grey; (second row) Mamie Schiller, Willie Riley, Jessie Drew, Mabel Gifford, and Kate Schiller; (third row) Anita Duran, Josie Crum, Mamie Mendenhall, Annie Lyon, Ida Hardison, Carrie Lyon, Lily Waldie, and Ruth Hardison. A Mr. Myers, a teacher, stands a little apart not looking at the camera. Perhaps he was camera shy, an attribute none of the children seem to share.

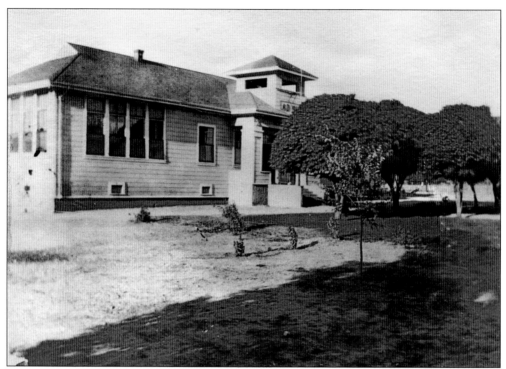

THE THIRD NEWHALL SCHOOLHOUSE. This schoolhouse served the locals until 1923, when the student population outgrew it. The school and its 4-acre site were sold to R. R. Reidel and Arthur B. Perkins for $1,000 an acre—the highest price ever paid for land in Newhall. They split the building into two homes. The Reidel house still stands today.

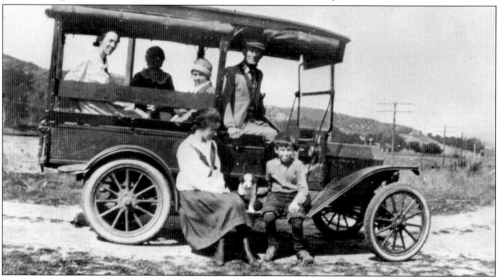

DILL'S SCHOOL BUS. Until the opening of William S. Hart High School in 1946, Newhall students attended San Fernando High School, meaning their days were at least 12 hours long. In 1918, David Dill started driving students to the high school and continued to do so into the 1940s. This was the first Newhall school bus, with Dill at the wheel and his children Ella and Robert on the running board.

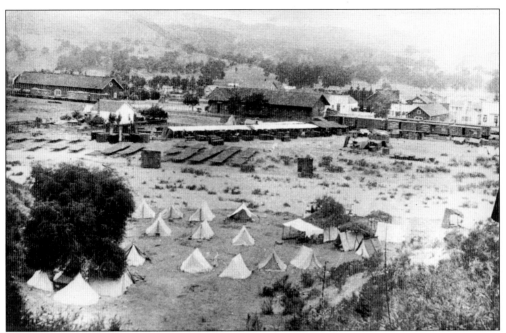

FRUIT DRYING, 1890. Growers in Ventura County shipped apricots and plums to dry in Newhall's hot, dry air. One year, a small twister lifted the drying trays high into the air, resulting in a 15-minute rain of fruit. The tents in the foreground housed the mostly Chinese labor force, and the Newhall train depot can be seen in the center background, with the warehouse to the left.

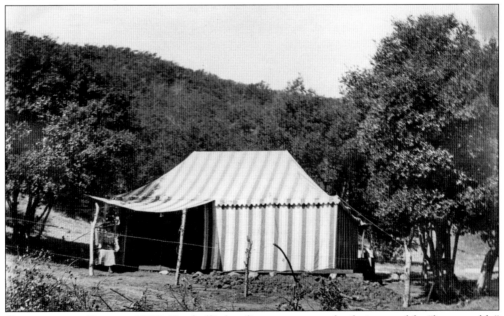

CONVALESCENT TENT, C. 1900. Newhall's dry climate was touted as being good for "lung trouble" of all kinds. This gaily striped tent, set up on the Hume Ranch a short distance from downtown Newhall, housed Mrs. M. H. Anderson of Santa Paula while she fought her illness. The treatment was recorded as being successful while it lasted, but she died after a premature return to the damper air of Santa Paula.

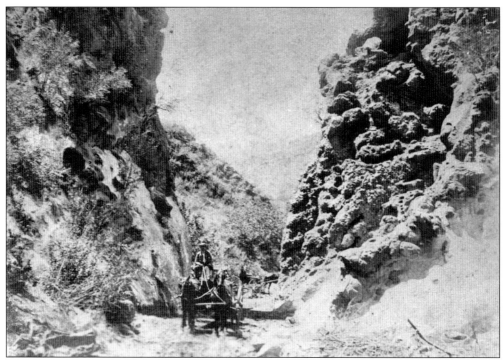

WILEY CANYON. Looking uncannily like Beale's Cut, this early photograph of Wiley Canyon on the west side of the valley shows just how rugged the many canyons around Newhall were. Wiley Canyon is off today's Lyons Avenue near the Interstate 5 junction and looks nothing like this currently.

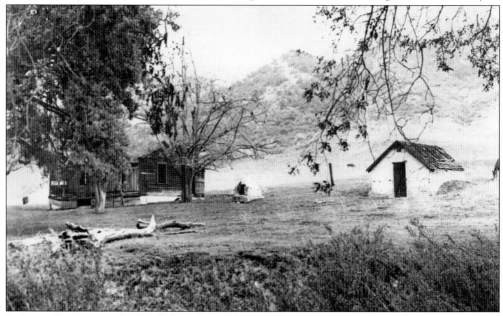

LaSALLE RANCH, 1963. Settled in the 1890s in Wiley Canyon, it remained a working ranch into the early 1960s. It was famous for its barbeques, with most of the food being prepared in the original beehive oven seen in the center of the photograph. The original ranch house can be seen on the left, and the small building on the right was used as a wine cellar.

Three

OIL IN THE HILLS

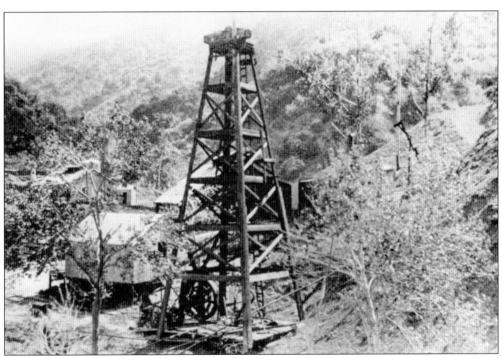

CALIFORNIA STAR OIL WELL NO. 4. The first commercially successful oil well in California, it was drilled in Pico Canyon in the early 1870s by the California Star Oil Works and came in a gusher after being deepened in September 1876. It continued to produce until it was shut down in the 1990s, making it the longest-producing oil well on record. This photograph was probably taken sometime in the early 1870s.

DEMETRIUS G. SCOFIELD.
Demetrius G. Scofield came to
Newhall from Pennsylvania and
realized the prospects in the area
were good. He started the California
Star Oil Works around 1875 after
buying Alec Mentry's claims. In 1879,
he recapitalized and changed the
company's name to the Pacific Coast
Oil Company. In the way of business,
Pacific Coast Oil became Standard
Oil of California, and Scofield was
president until his death in 1917.

ALEXANDER MENTRY. Born Charles
Alexander Mentrier in France in 1846,
Alexander Mentry came to Newhall in
1873 with experience in the Pennsylvania
oil fields that soon paid off. Men flocked
to work the Pico Canyon fields, and the
town that sprung up became known
as Mentryville. He married Flora May
Lake, who worked in the Derrick
Saloon. He died in 1900, a victim of
an allergic reaction to an insect bite.

Pico Canyon Works, 1877. Photographer Carleton E. Watkins visited the California Star Oil Works in June 1877. This photograph clearly shows the major redwood oil rigs near the CSO hill. The pipeline to the off-camera boiler can be seen suspended over the heads of the workers. Oil ran through a pipeline 5 miles to the refinery in Newhall, and water ran from Newhall to the works via a parallel pipeline.

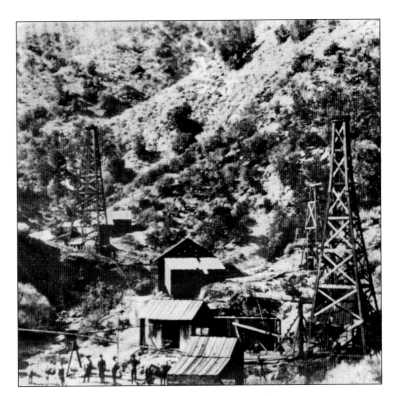

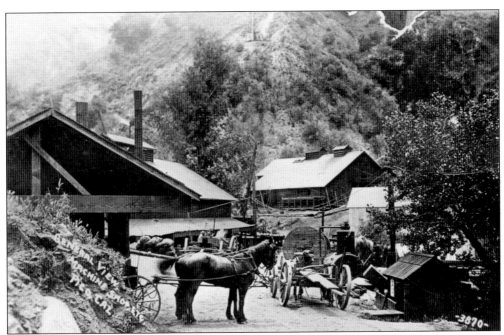

Pico Canyon Works, c. 1890s. The machine shop on the left was the heart of the operation, turning out any and all parts needed to keep the oil flowing. The big lathes were later moved to the Newhall Machine Shop and made their own contribution to World War II production. The blacksmith shop is seen in the center, with the roads to the PCO and CSO hills behind it.

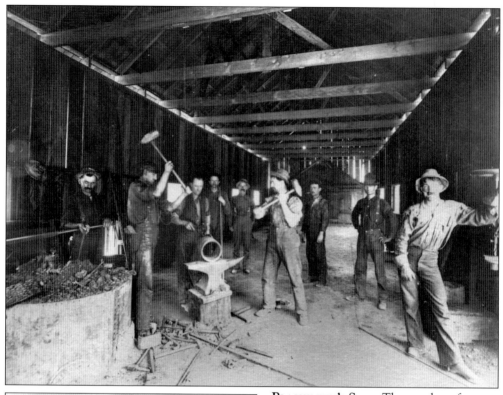

BLACKSMITH'S SHOP. The number of men in the picture may be atypical, but otherwise the scene is normal. Skilled blacksmiths worked in concert with the men of the machine shop to repair and sometimes make from scratch the all-important metal parts that kept the oil flowing, the horses moving, and the men employed.

JACK PLANT. The advent of steam power to drive drills changed how oil was produced, but it was not feasible for each well to have its own boiler. This is how the jack plant, a complicated spider web of cables supported by poles running back to the central boiler, became important. The boilers could then be better maintained and larger, meaning one boiler could power several drilling rigs simultaneously.

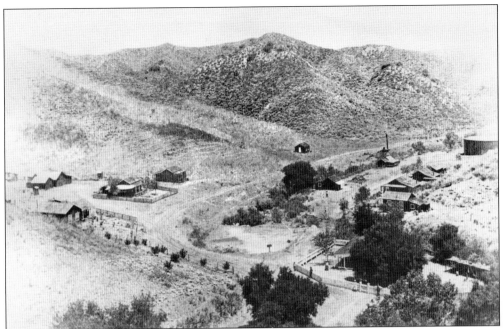

MENTRYVILLE, PICO CANYON. This 1883 photograph is probably the oldest view of Mentryville. Located about 5 miles from the town of Newhall, it grew up around the PCO and CSO hills to house the men who worked the rigs. Obscured by the large tree on the lower right is Supt. Alexander Mentry's 13-room house.

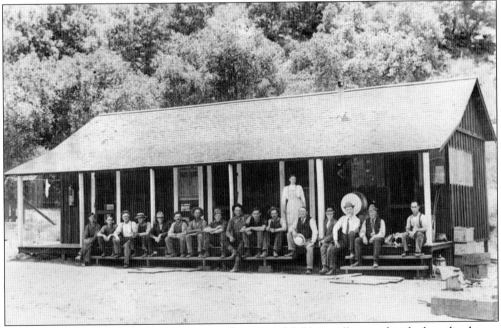

BOARDINGHOUSE, MENTRYVILLE. New arrivals in the oil fields usually stayed at the boardinghouse until they settled in. The company allowed workers to pitch tents or even build cabins on company property free of charge. Of course, if a new well was planned, the domicile had to be moved. Others preferred to stay in the relative comfort of the boardinghouse.

FELTON SCHOOL, MENTRYVILLE. Single men were not the only ones who came to Mentryville. The number of children in the growing town meant building a school in 1885. There was never a large student population, but it saved the children from having to make the difficult 5-mile trek into Newhall to attend classes. The school stayed open until the student population fell below the five-child minimum in 1932.

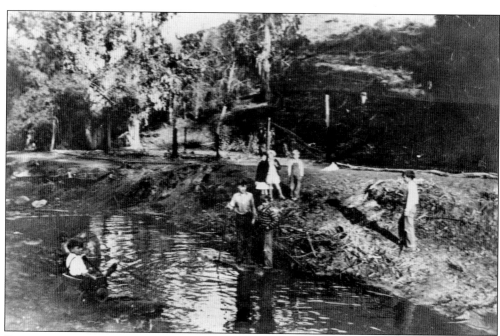

SWIMMING HOLE, MENTRYVILLE. The children of Mentryville made their own swimming hole by damming Pico Creek. Charles Sitzman took this picture in December 1929. From left to right are Philip Sitzman (in wagon), Ernest Wooldridge and Harry Dill on the raft, Beth Barton, Barbara Sitzman, Murray Dill, and Ted Dill.

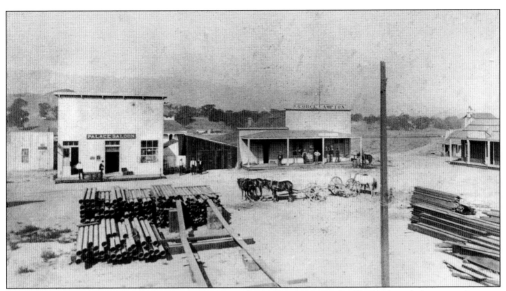

SUPPLIES FOR PICO CANYON. This shot from about 1880 of Newhall's Railroad Avenue shows a large load of pipes ready to be transported to the oil fields. In the background are Mike Powell's Palace Saloon, George Campton's store, and the Derrick Saloon on the far left. Just visible between the Palace Saloon and Campton's store is Campton's white house.

THE TELEGRAPH STAGE. The Telegraph Stage was another of Henry Mayo Newhall's ventures, and it served the outlying areas of the valley, carrying passengers, mail, and light freight to and from Newhall. The stage stop in Newhall was at the Southern Hotel, the porch of which can be seen behind Le Amromi's buckboard wagon, which was used on the route. (Courtesy of SCVHS.)

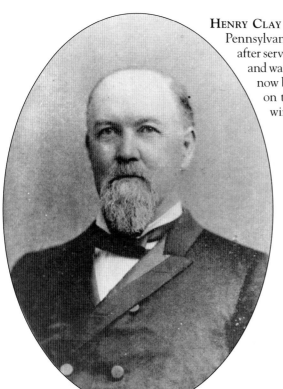

HENRY CLAY WILEY. Henry Clay Wiley was born in Pennsylvania in 1829 and made his way to California after serving in the army. He became involved in oil and was granted a claim in 1865 in the canyon that now bears his name. Stories of his stage station on the westerly side of the valley and wagon windlass are romantic but unconfirmed.

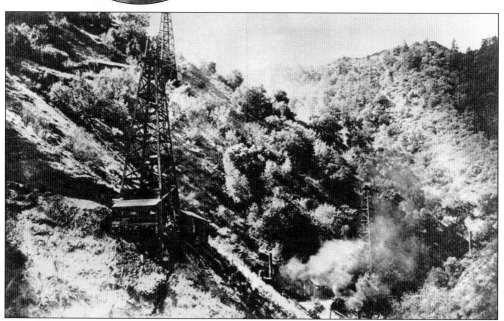

WILEY CANYON WELLS. Today Pico Canyon and Placerita Canyon are the first oil fields that come to mind, but most of the canyons in the valley held at least some oil and were explored and drilled, if only for a short time. Wiley had wells in Wiley Canyon in the 1860s and 1870s, as well as interests in nearby Elsmere and Towsley Canyon fields.

54

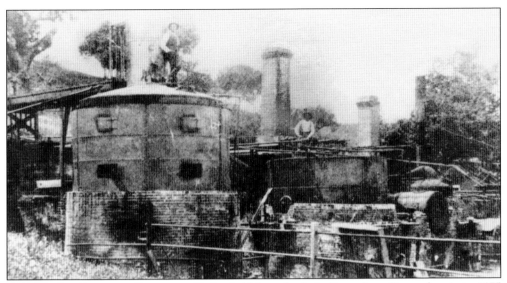

PIONEER OIL REFINERY. Demetrius G. Scofield brought J. A. Scott from Pennsylvania in 1875 to build California's first oil refinery to process the output from the Pico Canyon oil field. It had a top capacity of 22,000 barrels a year, producing mostly kerosene and benzene. As demand for these products fell, processing slowed and finally stopped in 1888. A California state landmark, it is the oldest surviving oil refinery in the world.

CALIFORNIA STAR OIL WORKS GUESTHOUSE AND OFFICE. Located on Pine Street close to the Pioneer Oil Refinery, the California Star Oil Works built this guesthouse for visiting VIPs. Amenities included a Chinese houseboy and a short ride to downtown Newhall. In later years, it served as the company's office and was sold in 1915.

PACIFIC COAST OIL WAREHOUSE, 1914. Built in 1883 by Lyman Stewart and Wallace Hardison as a general warehouse, they sold it to the Pacific Coast Oil Company in 1884. Later Frances Philips bought it from Standard Oil, converting it into a restaurant and boardinghouse. The building was torn down in 1932 and the lumber salvaged.

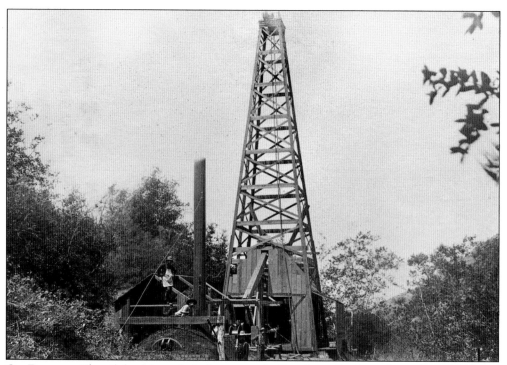

OIL DERRICK. The oil derricks and platforms were built to last of high-quality redwood. When a well ran dry, the wood was carefully salvaged and reused. If the company had no use for the wood, it was sold. More than one house in Newhall was built from recycled oil derricks.

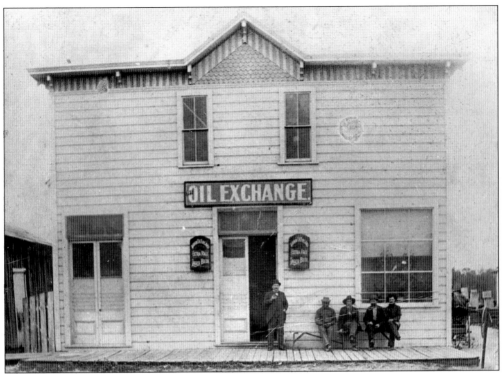

OIL EXCHANGE. The saloons in Newhall reflected the town's reliance on oil and the oilmen. As Mentryville was dry, the men came into Newhall to do their drinking. This was originally Mike Powell's Palace Saloon, but by 1890, it had become the Oil Exchange and was the high-class drinking establishment in Newhall.

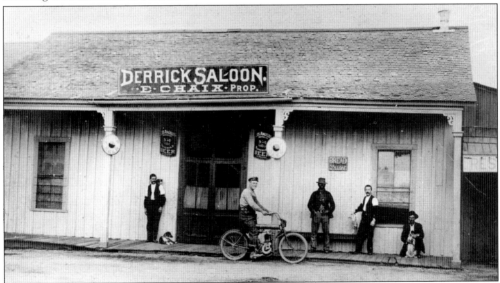

DERRICK SALOON. The Derrick Saloon was the working man's bar. Located on the corner of Railroad Avenue and Eighth Street, it burned down in 1915 in the same fire that took the Delano complex. Interestingly enough, from the 1880s to the present day, there has always been a bar on this site. Proprietor Emile Chaix stands with his dog in this 1910 photograph.

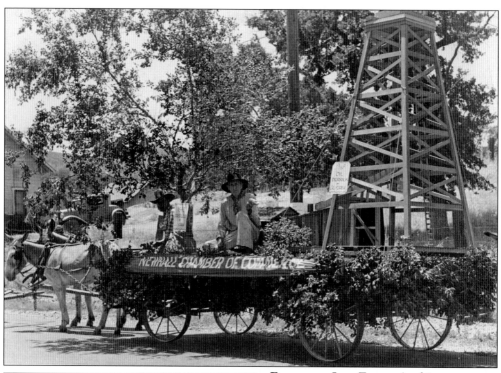

FOURTH OF JULY FLOAT. As this entry in Newhall's 1941 parade shows, oil was beginning to become a part of the town's nostalgic past for most people. Even though the wells were still producing, oil was no longer the primary source of jobs and prosperity. As new industries moved in, the townspeople saw a brighter future coming.

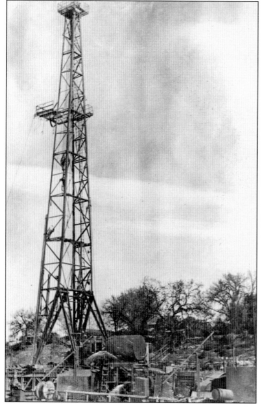

OLD FAITHFUL. Just when oil seemed to be fading away, Newhall's second big oil boom occurred. In 1948, Richard W. Sherman's wildcat well on Hill Street (Wayman Street today) blew in for 500 barrels on November 17, touching off wild speculation and an explosion of drilling in the low hills around Pico Road (Lyons Avenue today).

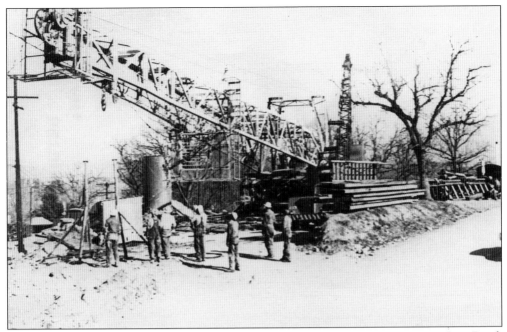

LEGION WELL. The Legion Well on Arcadia Street was drilled in January 1949 near Pico Road. Oil fever soared, and speculators offered as much as $15,000 an acre for leases. Amazingly, many landowners held out for more, believing that prices would rise. They were wrong; by March, the local paper headline read simply, "All Drilling on Newhall Townsite Leases Suspended."

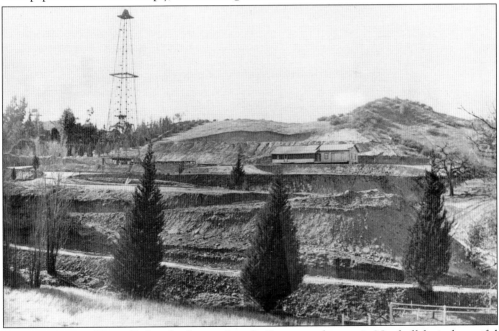

ARCADIA STREET WELL. Before the frenzy, Arcadia Street was known in Newhall for its beautiful homes and surroundings. The four-month bubble, like other oil booms before and after all over Southern California, left a legacy of dashed hopes, empty wallets, and newly barren landscapes that slowly recovered from the heady boom.

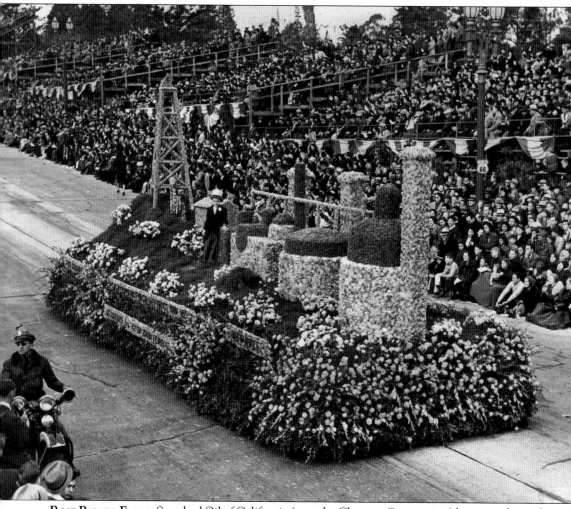

Rose Parade Float. Standard Oil of California (now the Chevron Corporation) has its traditional roots in the Pico Canyon oil field and the hard work of Demetrius G. Scofield and Alexander Mentry. The company celebrated those roots in an elaborate Rose Parade float, commemorating the Pioneer Oil Refinery, in the 1950s. (Courtesy of SCVHS.)

Four

EARLY SETTLERS

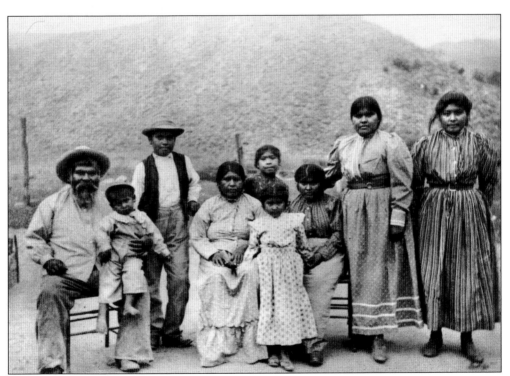

JUAN JOSE FUSTERO AND FAMILY. The first settlers of the valley were the Tataviam Indians. Juan Fustero, who died in 1921, claimed to be the last full-blooded Tataviam Indian, but anecdotal evidence seems to indicate that his wife was also a full-blooded Tataviam. Either way, only about 600 Los Angeles County residents could claim partial Tataviam parentage by the 1990s. (Courtesy of SCVHS.)

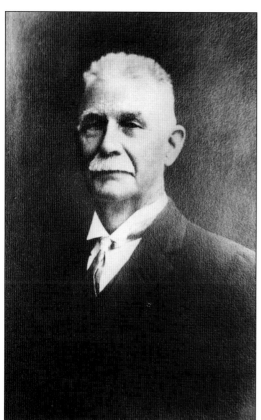

GEORGE CAMPTON. Born in the British West Indies in 1839, George Campton immigrated to the United States during the Civil War. He married native Californian Gregoria Soto and worked in various places before becoming superintendent of the Newhall Ranch in 1875. In late 1876, he opened his store at the original Newhall town site. He became a community leader, serving as the first postmaster and later on the school board.

CAMPTON HOME. Built in 1878 at the southwest corner of Eighth and Spruce Streets behind the store, the Campton home burned down when the ammunition in the back room of the store exploded and set the house on fire. Architecturally, the house appears to be a reused station house from the Southern Pacific Railroad. Examples of such houses survive to this day, including a restored one at Heritage Junction.

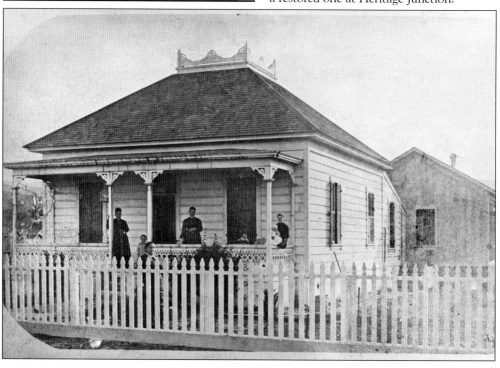

Joshua O. Newhall.
Joshua O. Newhall was born in Saugus, Massachusetts, and after moving to California, he worked as a clerk for Newhall Sons and Company auctioneers. He moved to Newhall to manage the first Southern Hotel for his uncle Henry Mayo Newhall. He later ran the general store after it moved out of the hotel and across the street into its own building.

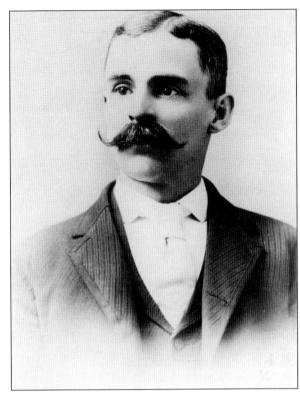

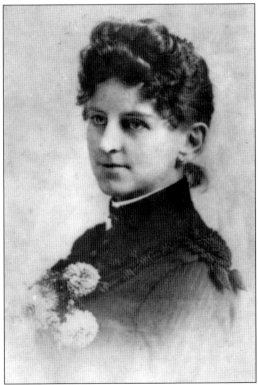

Laura E. Terry. Not much is known about Joshua O. Newhall's wife, Laura E. Terry, beyond that she was a popular novelist of her day. She moved to Newhall with her husband and set up housekeeping at 1½ Spruce Street, less than a block from the Southern Hotel, and later, the Newhall store.

JOHN T. GIFFORD. John T. Gifford was born in New York in 1847 and came to California in 1867. In 1875, he married Sarah Beckworth and became crew chief on the San Fernando Railroad tunnel dig. He stayed with Southern Pacific, becoming Newhall's original station agent, first working at the town's original location and then moving with the town in 1878. He retired in 1912 and remained in Newhall, dying in 1922.

SARAH BECKWORTH GIFFORD. Sarah Beckworth Gifford was born in England in 1853. Her family moved to Pennsylvania and then California, where she met and married John Gifford in San Diego 1875. Their first home at Newhall's original town site was a boxcar parked on a siding. The couple had one daughter, Mabel. Sarah died in 1945, one of the grande dames of Newhall society. (Courtesy of SCVHS.)

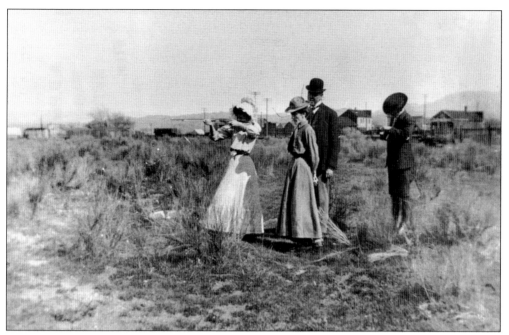

MABEL GIFFORD SHOOTING PARTY. The Gifford's daughter, Mabel, was one of Newhall's early belles. She was described as "one really pretty girl, a dead shot, with a weakness for fine horses." One of her favorite pastimes was to take her friends shooting in the open spaces behind her home. The town of Newhall can be seen in the background.

GIFFORD HOME. Not until 1894 did the Giffords have their own home built. Conveniently located just across the railroad tracks from the Newhall depot, it was well situated to allow John Gifford to stay on duty without having to spend long overtime hours in his office at the depot. The house survived well into the 1960s.

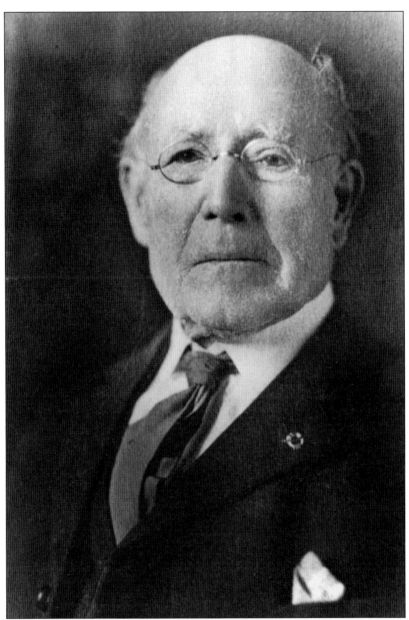

JUDGE JOHN F. POWELL. Larger than life, John F. Powell was born in Galway, Ireland, in 1835. His family moved to America when he was a toddler. As a 19-year-old navy lieutenant, he went to Africa to help suppress the slave trade, once working with Dr. David Livingston to free a camp full of slaves. He served in the U.S. Army during the Civil War, which brought him to California. Discharged in 1869, he homesteaded up in Dry Canyon (now Seco Canyon) until called upon to serve as judge for the enormous Soledad Judicial District. He moved to the new town of Newhall in 1878, where he built (or moved) his house on Railroad Avenue. He married Dora Lake, who worked at the Derrick Saloon, and they had three children. Her sister Flora May married Alexander Mentry. Powell was a successful entrepreneur, a philanthropist and community leader, and a dedicated justice of the peace. He died in 1925 and has the distinction of never having had a verdict overturned by a higher court. (Courtesy of SCVHS.)

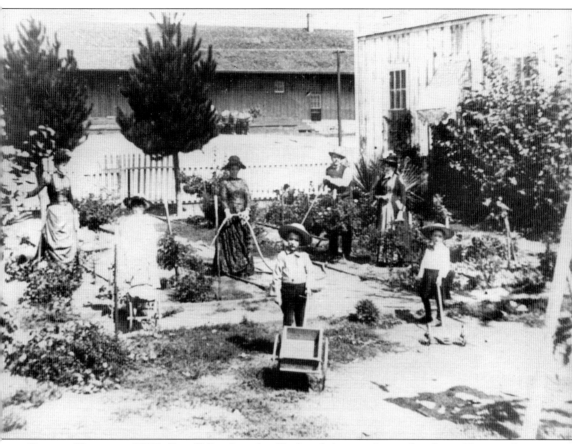

POWELL HOME, C. 1880. Powell lived in this Railroad Avenue house for about 20 years. In the Newhall tradition of moving homes and buildings around, he may have moved it from his homestead in Dry Canyon (Seco Canyon) to Newhall. The house held not only his family, but also his office and de facto courtroom for a time. Located near his brother Mike's Palace Saloon, he rented it to Mike for a few years while he worked out of town. Powell returned to the house for a few years and then moved to a new home at Eighth and Chestnut Streets only a few blocks away. Saloonkeeper Nick Rivera may have rented the house from him for a few years after that. The house survived until 1960, when it was finally razed. The picture shows Powell in a white shirt and dark vest, along with various members of his family, working in and enjoying the large garden behind the house.

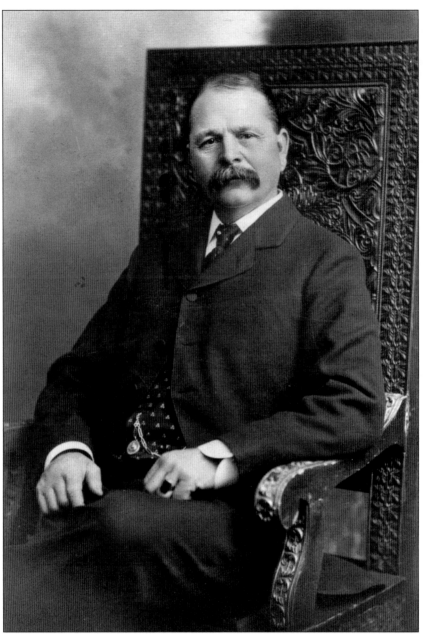

ED PARDEE. Ed Pardee (his full name is unknown) came to California from the Pennsylvania oil fields in 1883 and joined his brother Charles in the Pico Canyon. Perhaps it was the arrival of his wife and baby daughter from back east that prompted his move to Newhall, where he opened a livery stable around 1887. He was elected constable around 1893, working closely with justice of the peace John F. Powell. One of his fellow officers was McCoy Pyle, cofounder of Bowers Cave in 1884. In 1906, he was one of the constables signing work orders for the construction of the new jail that may or may not have replaced one that was bid in 1888. Interestingly, no one is certain whether the 1906 jail was a completely new building or a massive remodel of an existing jail. In 1913, Los Angeles became a chartered county, and he became an ex officio deputy sheriff when the Los Angeles Sheriff's Department took over policing the unincorporated county territories.

PARDEE HOME. Pardee and his wife, Catherine, are seen here enjoying the garden of their home. The house was built in 1890 on Pine Street by Henry Clay Needham as a Good Templars hall. Pardee bought it 1893 and moved it to the Newhall Avenue triangle (site of today's Veteran's Park), converting it into the family home. Later the house was used by Tom Mix as a dressing room because it was close to his miniature Mixville behind the Presbyterian church. There are rumors that he entertained ladies there as well. In 1946, Pearl Pardee Russell sold the house to the Pacific Telephone and Telegraph Company, which used it as an exchange. From 1969 to 1977, it was the home of the Boys Club (later the Boys and Girls Club) and then became the home of the chamber of commerce until 1987, when the house reverted to the Pacific Bell Telephone Company. The house was donated to the Santa Clarita Valley Historical Society and was moved to Heritage Junction Historic Park in 1992. It is currently undergoing renovation with plans to turn it into a museum.

PEARL PARDEE RUSSELL. Pearl Pardee Russell was another of Newhall's early belles. Strikingly beautiful, she was frequently named "queen of the ball" at dances in Newhall. In 1916, she was one of the founders of the Newhall Parent Teachers Association, an organization that worked tirelessly for years to improve educational opportunities for the children of Newhall and the surrounding area.

SING KEE. Once the railroad tunnel was completed, many of the Chinese workers remained in and around Newhall, trying their hands at gold mining or working as servants. Even so, there never was a Chinese community, as they moved on in search of other opportunities. The subject of this undated photograph is identified as Sing Kee. He and his wife, Mary, were buried in Lyon Station Cemetery.

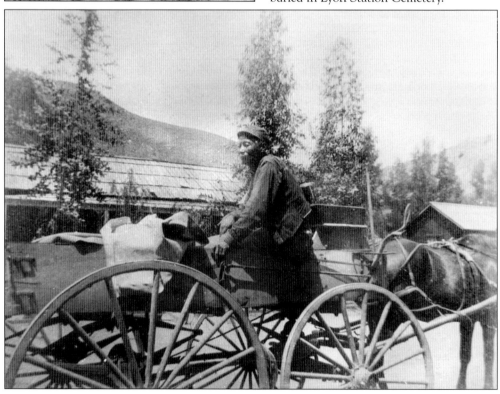

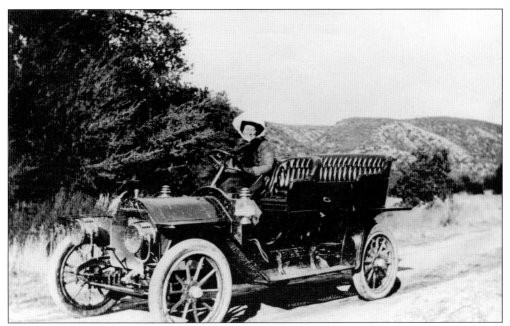

FRANCES PHILLIPS. Frances Phillips, a local widow and boardinghouse keeper, was the first person in Newhall to buy a car. She went first class with a new 1908 Cadillac Model T touring car with optional headlamps and Cape Cart top. No wonder people still speculate on the exact nature of her boardinghouse.

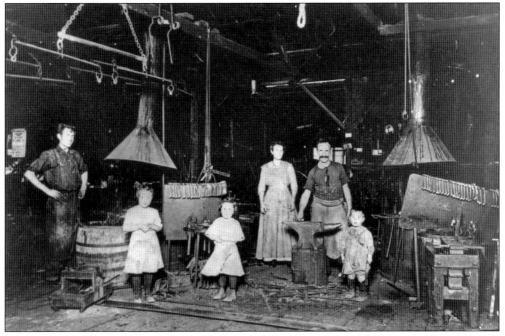

THOMAS MCNAUGHTON FREW II. Thomas McNaughton Frew II arrived from Scotland in 1900 with his tools and established a business that would last for 70 years and three generations. His shop, which he bought for $400, was on Spruce Street between Market and Eighth Streets. He is seen here in his shop with his wife, Evangeline, and some of their 11 children. (Courtesy of SCVHS.)

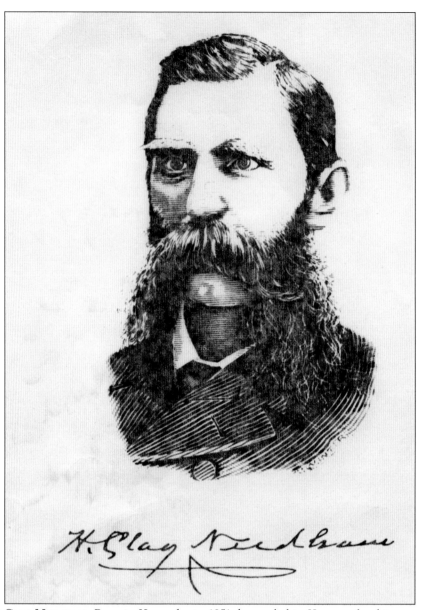

HENRY CLAY NEEDHAM. Born in Kentucky in 1851, he settled in Kansas after his marriage in 1879 and entered politics. He soon became prominent in the prohibitionist movement, giving speeches far and wide. He came to Newhall in 1888 to manage the proposed St. John's Subdivision, a prohibitionist colony in Newhall. The project failed, possibly due in part to the proviso that any homeowner caught with liquor on his property would forfeit ownership. Needham went into the lumber business, later establishing Newhall's first water system. He was a charter member of the First Presbyterian Church. While a dedicated prohibitionist, he never failed to distinguish between the sinner and the sin, often paying the fines of the men he had arrested for drunkenness—if they promised to stay sober. His political career was never successful, although he was much in demand as a speaker. He was nearly the Prohibition Party's candidate for president (or vice president, accounts differ) for the 1932 national election, but ill health forced him to withdraw. He died in 1936, widely mourned and fondly remembered. (Courtesy of SCVHS.)

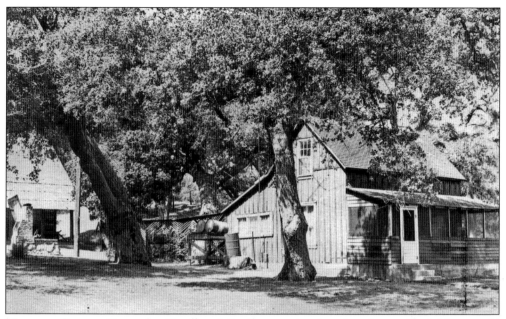

NEEDHAM RANCH. Even after Needham's family moved to Los Angeles so the children could attend high school, they continued to visit the ranch. For Needham, it was a refuge from his busy public life, and he particularly enjoyed simply sitting and watching the wildlife. His heirs sold the property in 1957, and part of it became the Eternal Valley Cemetery.

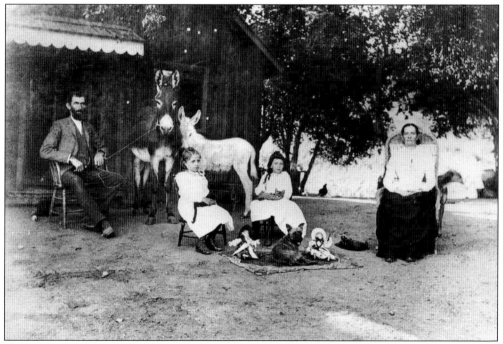

ALEXANDER HUME AND FAMILY. This charming photograph, taken around 1890, gathers the entire Hume family, including cherished dolls and pets. The Hume ranch was on San Fernando Road toward Lyon Station. In 1891, Alexander Hume was one of the five directors named on the articles of incorporation filed by the First Presbyterian Church in Newhall.

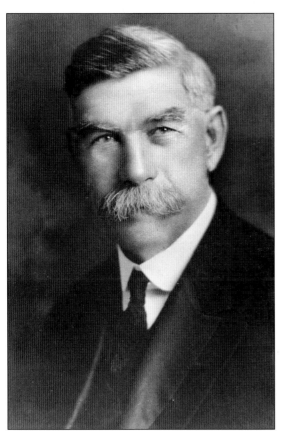

REV. WOLCOTT EVANS. Rev. Wolcott Evans arrived in Newhall in 1914 and worked hard to serve his congregation at the First Presbyterian Church and the community, raising funds and support to build a new church to replace the aging structure that could no longer fulfill the church's needs. Many spoke of him as a rock during the aftermath of the St. Francis Dam disaster, tirelessly offering what aid and comfort he could. He retired in 1930.

BUILDING THE PARSONAGE. To celebrate the arrival of Evans, volunteers built a new parsonage on Market Street, which still stands today. From left to right are (first row) George Frew, Eddie Kichline, and Warren Graff; (second row) unidentified, ? Kellogg, a Mrs. Thibadeau, Mrs. Clyde Reynolds (holding hat), Rev. Wolcott Evans, ? Evans, two unidentified, Leroy Clint, three unidentified, Jack Wayman (framed in window), and Bert Russell (in front of Wayman).

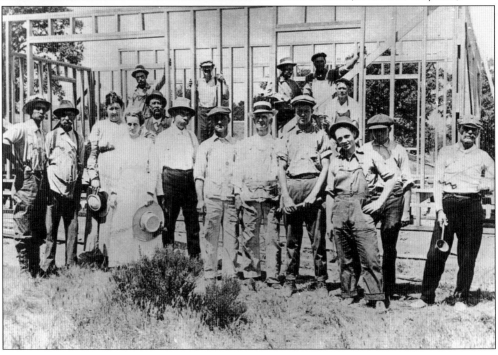

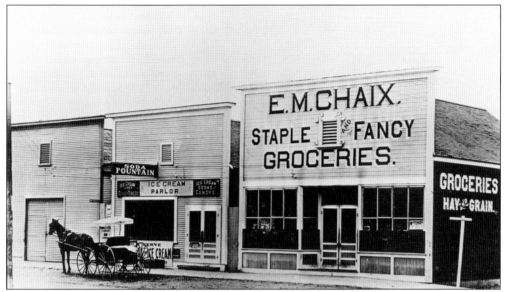

EMILE CHAIX. One of Newhall's many entrepreneurs, Emile Chaix took over the Derrick Saloon in 1908 and ran it successfully for many years. Around 1913, he joined the movement to Spruce Street and opened this grocery store at the southwest corner of Eighth and Spruce Streets. Soon after, to capitalize on the growing popularity of the automobile, he ran a vulcanizing shop on Spruce Street until the late 1920s.

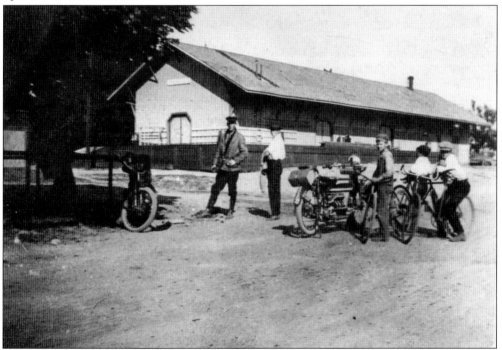

FLOYD ANSON. Floyd Anson was a local boy with a passion for motorcycles. The day the Newhall Tunnel opened, he was one of the first through it. No one was keeping track, but it is probably safe to say that he was the first motorcyclist through the tunnel. This 1914 photograph shows him with other enthusiasts in front of the Standard Oil Warehouse on Railroad Avenue.

LILLIE MAYHUE. The Mayhue family arrived in the Newhall area in 1893 from the Tennessee-Kentucky border. Close friends of the Needham family, William Mayhue and his wife, Pallie Mayhue, named their elder daughter Lillie after Lillie Needham. The family first settled in the Rice Canyon oil fields, where Pallie ran the boardinghouse while William worked in the oil fields. (Courtesy of SCVHS.)

MAYHUE HOME. The Mayhue family moved to this home in Newhall at the corner of Ninth and Chestnut Streets some time before 1906, when William bought the old Newhall Store from James Gulley. He also farmed in what is now Valencia on a lease from the Newhall Land and Farming Company. (Courtesy of SCVHS.)

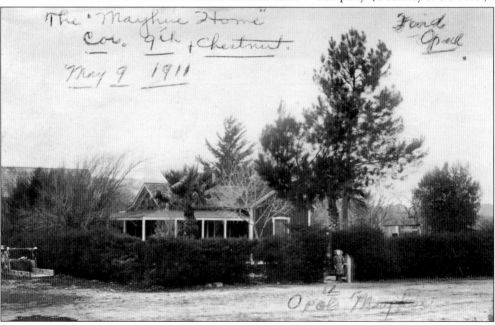

LLOYD HOUGHTON. Lloyd Houghton arrived in Newhall in 1919 and soon became known for his irrepressible sense of humor. That same year, he bought the former Newhall Store from William Mayhue and converted it to the Hap-A-Land dance hall and meeting rooms. In an unrelated transaction, he married William's daughter Opal.

ARTHUR B. PERKINS. Arthur B. Perkins came to Newhall in 1919 and bought the water company from Henry Clay Needham. He soon became interested in local history and began collecting photographs and stories. By the time he sold the water company in the late 1950s and retired, he was a respected local historian with many articles to his credit. Both he and his wife, Marguerite, were active community leaders.

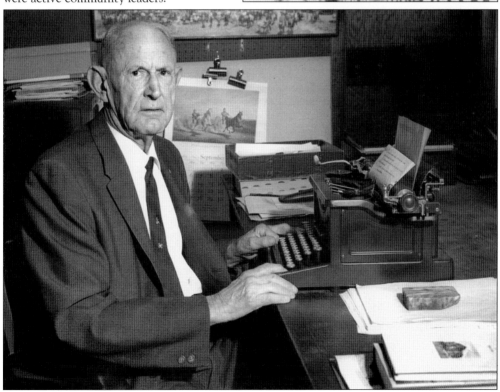

Lucretia del Valle. Born in 1892, she was far more than a pretty face. In 1912, she debuted in *The Mission Play*, a drama of early California. Clad in her grandmother's old clothes, she brought undeniable authenticity to the long-running pageant, starring in 850 performances. However, she did not pursue acting and instead followed her father, Senator Reginald F. del Valle, with whom she had gone on diplomatic missions to Mexico along the political trail. She married Henry Francis Grady in 1917, a future ambassador to India, Greece, and Iran, and became prominent in the California Democratic Party in her own right, serving as a California delegate at the Democratic National Convention in 1928, 1936, and 1956, and as an alternate in 1940. She was also a presidential elector for California in 1944. She died in 1972. (Courtesy of SCVHS.)

Five

DISCOVERED BY
HOLLYWOOD

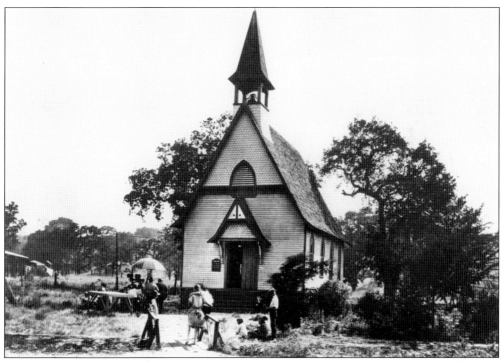

FILMING AT THE CHURCH. Newhall's Western flavor, open spaces, and proximity to Hollywood made it a favorite location from the earliest days of the movie industry. The Presbyterian church was a favorite location of Charlie Chaplin and others for its photogenic qualities, convenient location just a few blocks from downtown, and open setting. Locals often picked up a little cash working as extras or crew.

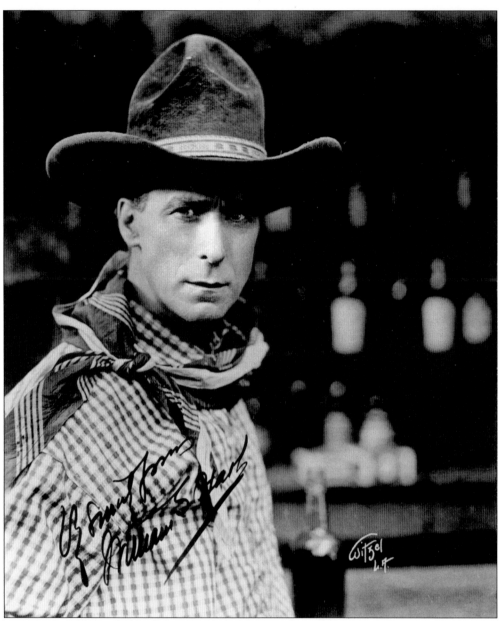

WILLIAM S. HART. Probably the iconic silent movie cowboy, William Surrey Hart started out on the stage in New York, becoming a successful Shakespearean actor. Not eager to make movies, it was the New York–born actor's fascination with the Old West that led him to the screen. His first film was released in 1914 when he was 49 years old. Like all his movies, it was gritty and realistic, with strong moral undercurrents. But by the early 1920s, audiences were being charmed by the likes of Tom Mix and Hoot Gibson. He made his last movie, *Tumbleweeds*, in 1925 amid dwindling popularity, partially due to bad publicity around a paternity suit and his disintegrating marriage to Winifred Westover. Now considered a classic, the film did not do well at the box office and sealed Hart's disenchantment with Hollywood. He retired to his Horseshoe Ranch in Newhall and was a fixture in town until his death in 1946 at the age of 81. Clips from his movie *Dealing with Daisy* played in Disneyland's Main Street Cinema from 1955 until the 1980s.

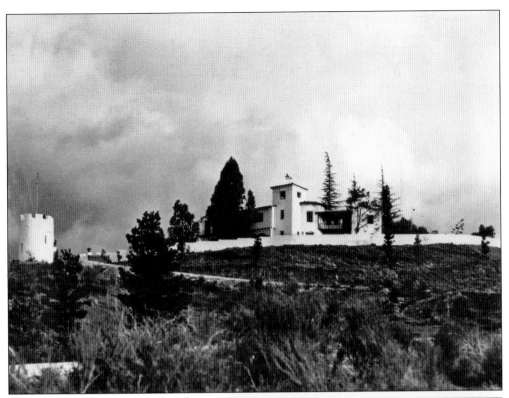

HART CASTLE. In 1921, Hart bought a small ranch and built a Spanish Colonial Revival mansion atop a hill overlooking downtown Newhall. He named the house La Loma de los Vientos (Hill of the Winds), but the locals immediately dubbed it Hart Castle. He filled it with a comfortable mix of Western art, Native American artifacts, and memorabilia. The bison herd was a gift from Walt Disney in 1962.

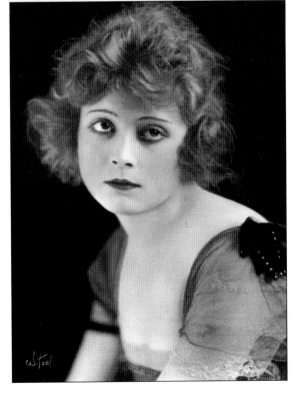

JANE NOVAK. The niece of film star Anne Schafer, Jane Novak began her career in 1913, soon appearing with Hollywood's elite, including Tom Mix, Harold Lloyd, and Hart. She and Hart were quietly engaged but did not marry. It seems likely that Hart's possessive sister Mary Ellen interfered, as she did in his only marriage. Novak's transition to talkies was rough, and her career faded. (Courtesy of SCVHS.)

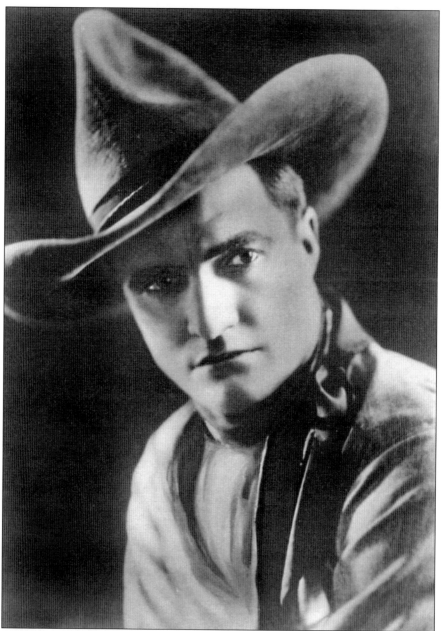

Tom Mix. Born in 1880, Tom Mix started making movies in 1910, becoming the most popular cowboy star of his day. An early action star who believed in giving the fans their money's worth, his movies featured not only his riding and shooting skills, but also his horse, Tony, who was famous in his own right. However, his insistence on doing most of his own stunts resulted in repeated injuries that shortened his career. He enjoyed a showy Hollywood lifestyle but retired permanently from the business in 1935, having made more than 300 movies. He performed with circuses intermittently during the 1930s, apparently enjoying himself tremendously. He died in a 1940 car crash but remained an icon on radio and in comic books for over a decade. Along with William S. Hart, he was one of Wyatt Earp's pallbearers. He is famously said to have wept at the funeral. (Courtesy of SCVHS.)

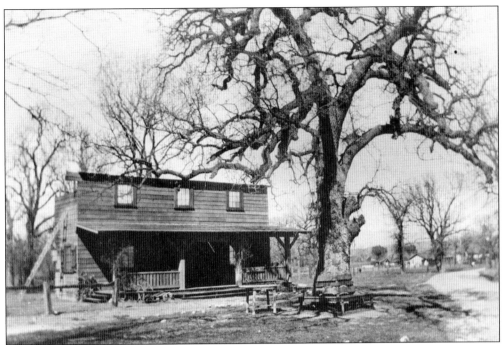

MIXVILLE SET. Cowboy star Mix liked to build semipermanent sets for his movies, known as "Mixvilles." One of his largest Mixvilles was built at the Edendale lot on 12 acres. It was a complete frontier town loaded with Western props and furnishings, complete with a dusty street, hitching posts, and buildings. The set also included, in separate areas, a Native American village ringing by miniature mountains, a desert, and a large corral and ranch house. The miniature Mixville shown in these photographs from about 1915 cannot compare in size, but the setting is authentic Old West, with some of Newhall's buildings visible in the background. Note the ladder and unfinished roof in the above photograph; often buildings were left open to the sky to facilitate interior filming.

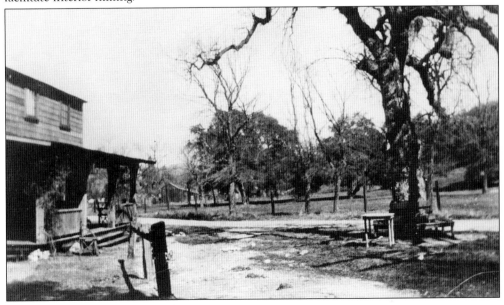

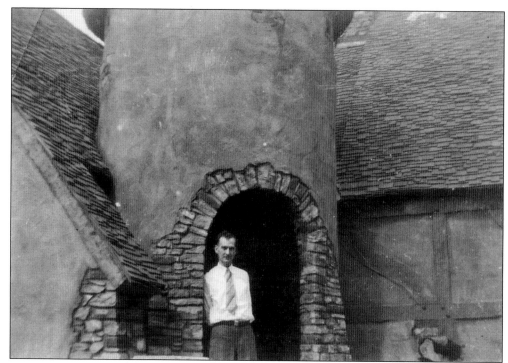

CHARLES MACK. Charles Mack was half of the Two Black Crows, a blackface comedy act in the 1920s and 1930s. Along with his main partner, George Moran, their act was corny and often non-racial, with one quick and one slow character, but their relationship and laconic delivery led to great success in vaudeville, Broadway, radio, phonograph records, and film. He died in a 1934 automobile accident. (Courtesy of SCVHS.)

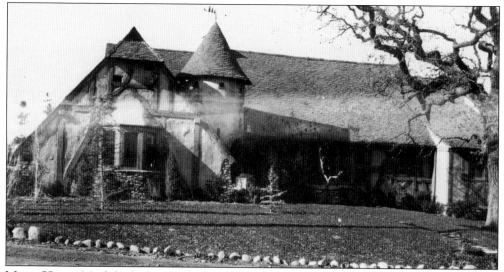

MACK HOME. Mack built this fanciful home, one of a pair, on Eighth Street in Newhall. He often hosted friends in the entertainment industry, including Wallace Beery and W. C. Fields, who rented the house for a time in the 1930s. Still standing, it is one of Newhall's little-known architectural treasures and a fine example of the short-lived storybook style of architecture that was popular in southern California in the 1920s and 1930s. (Courtesy of SCVHS.)

ROSE OF THE RIO GRANDE POSTER. Zorro creator Johnston McCulley wrote the story for this 1938 Monogram Pictures release, featuring the Zorro-like El Gato in an exciting tale set in old Mexico. The movie featured several songs, including *Ride, Amigos Ride*, which became a signature tune in Monogram's Cisco Kid Westerns of the mid-1940s. (Courtesy of SCVHS.)

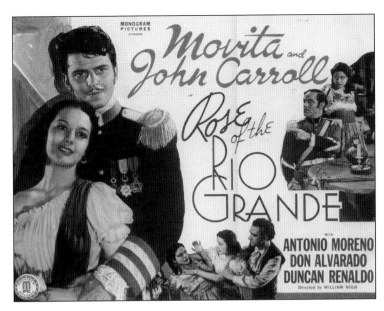

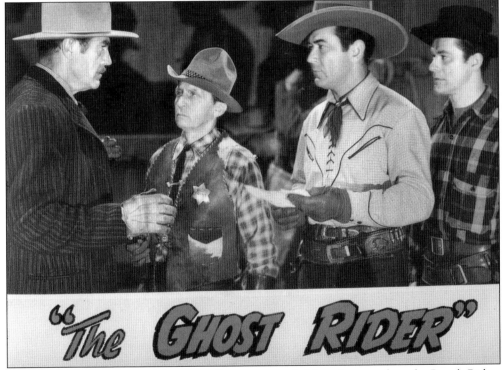

THE GHOST RIDER POSTER. Monogram Pictures created this series to replace the Rough Riders series after the death of its star, Buck Jones. Johnny Mack Brown played Nevada Jack MacKenzie in his adventures as an undercover U.S. Marshall, joined by Raymond Hatton, reprising his role as Sandy Hopkins from the earlier series. (Courtesy of SCVHS.)

HARRY CAREY. His career started in silent movies and transitioned successfully to talkies over a nearly 40-year career. He and his wife, Olive, bought a ranch in San Francisquito Canyon in 1920, living there with their two children. It was partially destroyed in 1928 when the dam burst. They rebuilt, and the restored ranch still exists today. He died in 1947. (Courtesy of SCVHS.)

OLIVE CAREY. Olive (Fuller Golden) Carey made her first movie at age 18 in 1914. She retired in 1916 after marrying Harry Carey and returned briefly to acting in the 1930s and again after her husband's death in 1947, continuing until 1966. She championed the career of young actor John Wayne, who became the lasting icon of the movie cowboy, and he never forgot her help. (Courtesy of SCVHS.)

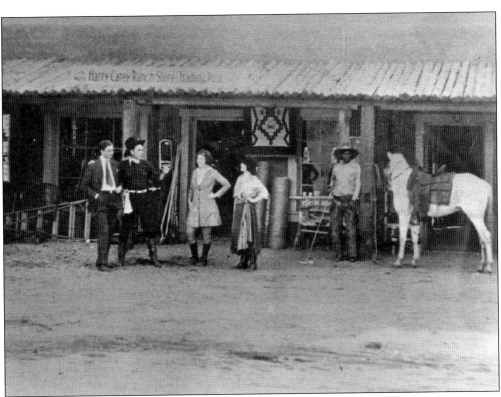

HARRY CAREY TRADING POST. Built in the early 1920s, it was a tourist attraction that presented a romanticized view of the Old West. The largely Navajo Indian staff Carey had met while filming on location was another draw. The trading post was washed away when the St. Francis Dam broke in 1928. The ranch house survived, and the complex has been restored and opened to the public. (Courtesy of SCVHS.)

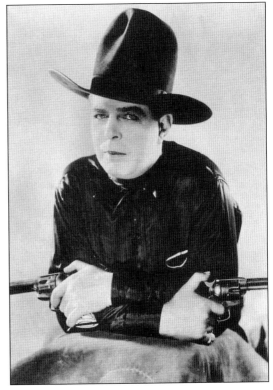

HOOT GIBSON. Born Edmund Richard Gibson in Nebraska in 1892, he became one of the first movie stuntmen around 1910 and one of Hollywood's superstar cowboys soon after returning from World War I. Audiences loved his boyish demeanor and tongue-in-cheek performances. He made many movies in and around Newhall and at one point owned the rodeo arena in Saugus, the site of today's Saugus Swap Meet. (Courtesy of SCVHS.)

TEX PALMER. Tex Palmer was a popular B-movie Western actor, with most of his film appearances occurring between 1932 and 1947. He easily made the move to television Westerns in the 1950s and appeared multiple times on *Gene Autry's Melody Ranch* television show. In this picture, Palmer is driving a stagecoach in Newhall's 1952 Fourth of July parade, one of many actors to make an appearance in the event over the years.

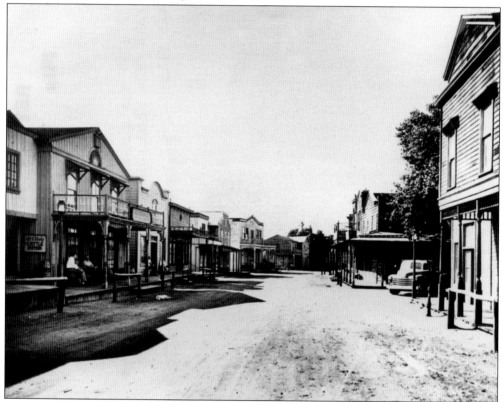

MELODY RANCH. Opened in 1915 by Monogram Pictures studio, more than 750 Westerns were filmed here before Gene Autry bought the ranch in 1952. Film production continued until the 1962 fire that ended an era. After being sold to the Veluzat brothers, the Western part of the movie ranch was rebuilt, and filming resumed with such productions as *Deadwood*. It also serves as the focus of the annual Cowboy Festival.

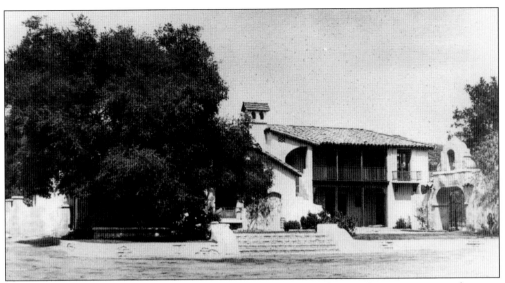

MEXICAN BUILDINGS AT MELODY RANCH. While best known for its Western town standing set, Monogram Ranch also boasted a beautiful Mexican, or early Spanish California, standing set. Used for both English- and Spanish-language movies, the set was shown to advantage in such movies as Monograms Pictures' 1938 movie *Rose of the Rio Grande*. These photographs were probably taken in the late 1950s or early 1960s before the devastating fire that destroyed much of the ranch. The Mexican set largely survived the blaze, and the buildings could be glimpsed through the trees while driving through Placerita Canyon. The above photograph shows the impressive hacienda building, and the one below shows the beautiful church.

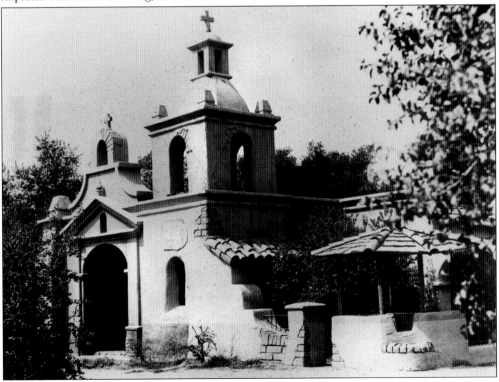

TUMBLING TUMBLEWEEDS

by
BOB NOLAN

Sung by
GENE AUTRY

in

"TUMBLING
TUMBLEWEEDS"

A REPUBLIC PICTURE

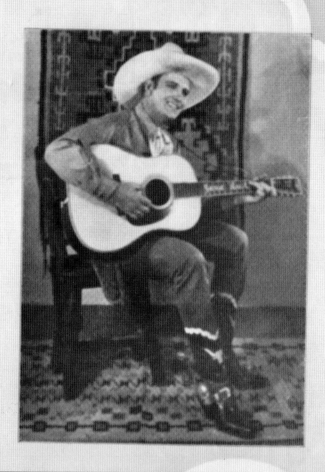

GENE AUTRY. Known as the "Singing Cowboy," Gene Autry already had a successful music career when he began making movies in 1934. By 1937, he was America's top Western box office star and maintained that popularity until the rise of Roy Rogers during Autry's World War II service. Undaunted by the shift, he starred on *Gene Autry's Melody Ranch* radio show from 1940 to 1956, when he moved to television and produced *The Gene Autry Show*. His horse, Champion, also had his own radio show, *The Adventures of Champion*, and was a star in his own right. Champion lived at Melody Ranch until his death in 1990. Autry retired from show business in 1964 after making nearly 199 movies and recording more than 600 songs. Some of biggest hits were Christmas and children's songs, including "Rudolph the Red-Nosed Reindeer" and "Peter Cottontail," along with his signature song "Back in the Saddle Again." (Courtesy of SCVHS.)

Six

FROM TOWNSHIP TO TOWN

CHAMBER OF COMMERCE BROCHURE. In the 1930s, Newhall's civic leaders began to seriously look at getting their piece of the rapidly developing Southern California dream for their aging town. Obviously the town needed better roads and services, more businesses, expanded schooling, and housing that followed the more urban mode becoming popular. They had their work cut out for them.

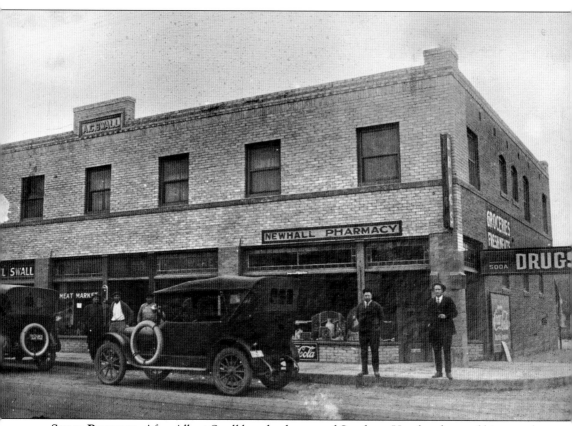

Swall Building. After Albert Swall bought the second Southern Hotel and moved his store, he realized that other businesses would follow, given the opportunity. So he built the Swall building directly opposite the second Southern Hotel on Spruce Street. He went first class, erecting a two-story brick building with electric lights and other amenities. It was barely completed when the Southern Hotel burned down. The heat from the fire was so intense that it popped the windows out of the Swall building. The new hotel and business block anchored the transition from Railroad Avenue to Spruce Street for Newhall businesses. Spruce Street has remained an important part of Newhall though several name changes (Spruce Street to San Fernando Road to Main Street). The original tenant, Newhall Pharmacy, outlasted the building, which was badly damaged in the 1971 earthquake and was practically rebuilt from the foundations up. This picture was taken in 1914 and shows Albert Swall (left) and Nick Rivera (right) standing on the corner in front.

NEWHALL DEPOT IN LATER YEARS. Once regular passenger service was discontinued in 1933, Haddad and Butler vegetable wholesalers repurposed the Newhall depot as a packing shed and shipping hub. The abandoned depot burned down in 1962. In 2000, Newhall's Metrolink station was built on the site.

NEWHALL STORE BEFORE DEMOLITION. After the Masonic club meeting in the former Mayhue store on March 17, 1928, L. M. Hall headed for home, the Edison substation near Castaic. He arrived in time to get his wife and two children up a telephone pole above the devastating wave of water from the St. Francis Dam break. They were among the few lucky ones.

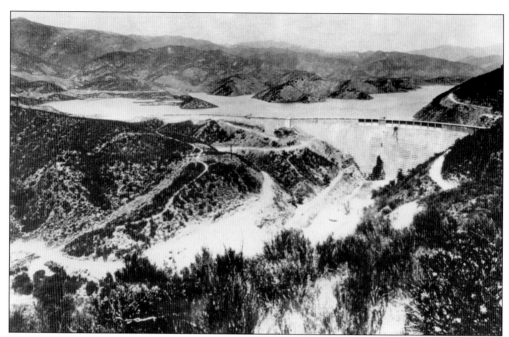

THE ST. FRANCIS DAM BEFORE AND AFTER. In 1925, the Los Angeles Bureau of Water and Power started building a huge reservoir near the head of San Francisquito Canyon without public fanfare. The Newhall Land and Farming Company and the Santa Clara River Protective Association quickly lodged protests on the grounds of diversion of water and public safety. Bureau head William Mulholland ignored the protests. From the beginning, the dam leaked, but the leaks were ignored. New leaks were inspected on March 16 and were deemed insignificant. On the night of March 17, 1928, the dam broke without warning, sending a wall of water to the ocean some 54 miles away. No one knows exactly how many people died that night, but skeletons still occasionally turn up along the flood's path.

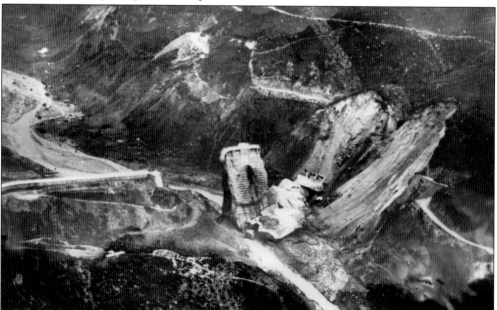

VICTIMS OF THE ST. FRANCIS DAM DISASTER. The Hap-A-Land dance hall became one of many temporary morgues to hold the more than 470 victims of the disaster. This morgue held around 78 bodies and was set up to receive victims within a few hours of the break. Later the Hap-A-Land became a victim itself, as people did not want to dance in the former morgue. Owner Lloyd Houghton sold the building to the Masonic club.

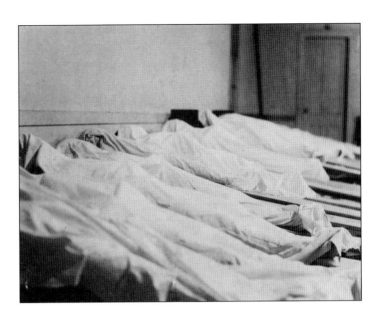

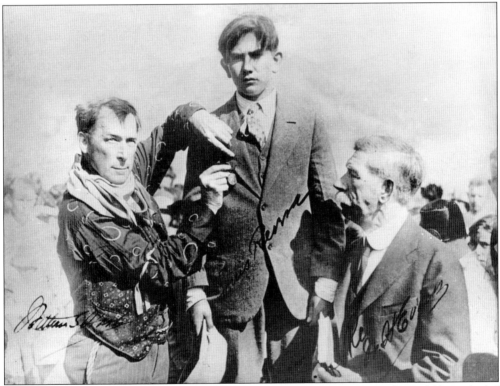

ST. FRANCIS DAM DISASTER HERO. When the dam broke, many more people would have died if not for myriad individual acts of bravery in warning and evacuating people from the water's path and rescuing those who survived the initial wave of devastation. Here Luis Rivera is honored by William S. Hart and Rev. Wolcott Evans for his bravery on that horrible night.

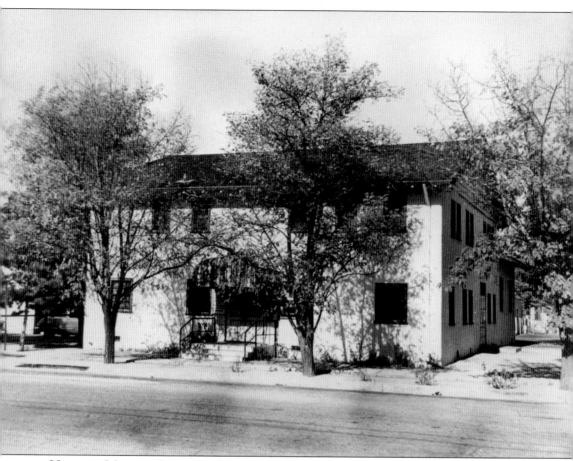

Newhall Masonic Building. The Masonic Building Society formed around 1930 with the express intent of building an income-producing property in downtown Newhall that would also serve as a their meeting place. Bucking the trend to Spruce Street, they bought the aging Mayhue store, where they had been meeting, from Lloyd Houghton. They demolished it and built their two-story building in 1931. It served not only as their meeting place, but also as the courthouse and constable's office for the valley for many years, and it replaced the vanished Hap-A-Land as a favorite venue for social events and meetings. The Masonic Building Society maintained ownership of the building until the late 1950s, when it was sold due to rising costs and shrinking income. In keeping with the original charter, once debts were paid, the profits were distributed among the members and the books closed permanently.

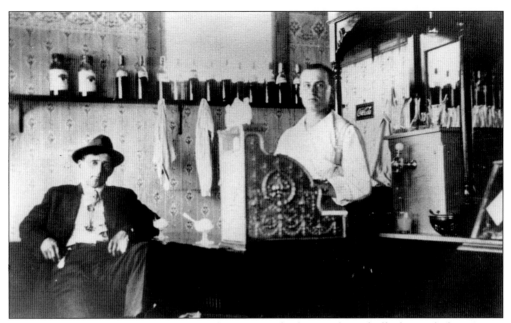

SODA FOUNTAIN AND FIRST LIBRARY. Robert F. Woodard opened Newhall's first soda fountain in 1913. One of the new buildings on Spruce Street (near the corner of Eighth Street), it also served as a lending library. Mrs. Woodard was the volunteer librarian, and the books were occasionally restocked by the Los Angeles Public library. When the new branch library was built, some of the bookshelves were moved to the new building.

DEDICATION OF NEWHALL LIBRARY. In 1957, Newhall had an official county library open. Shown here are the leading lights in the success. From left to right are county librarian John Henderson, Paul Plamer, Judge C. M. MacDougal, Arthur B. Perkins, and Los Angeles County supervisor Warren Dorn. The library is still in its original building at the corner of Ninth and Walnut Streets.

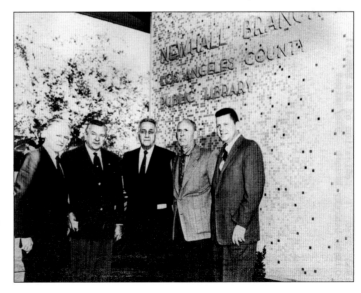

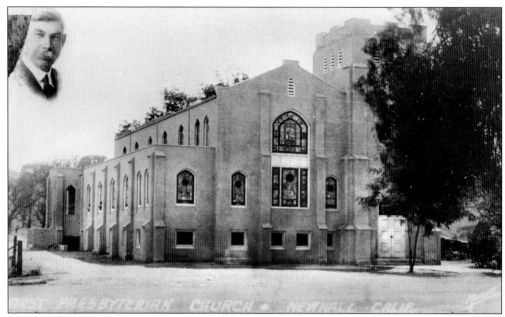

SECOND PRESBYTERIAN CHURCH. This impressive Gothic-style church was built in 1925 under the watchful eye of Rev. Wolcott Evans (inset). It stood on Newhall Avenue near Market Street until being damaged beyond repair in the 1971 earthquake. What stained glass survived was sold, much to the consternation of local residents. Today the site is a playground, with the replacement church farther down the block near Eighth Street.

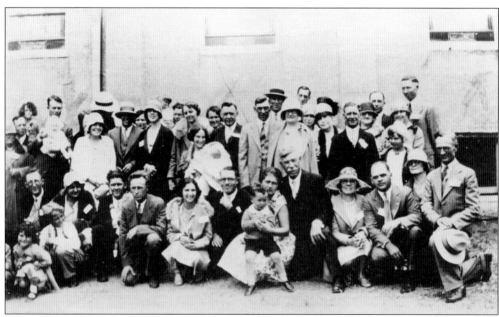

REV. WOLCOTT EVANS AND COUPLES. A modest celebration of Evans's career, this picture shows him (kneeling, center right) by the side of the new church surrounded by a few of the many couples he married in both the old and new Presbyterian churches in Newhall.

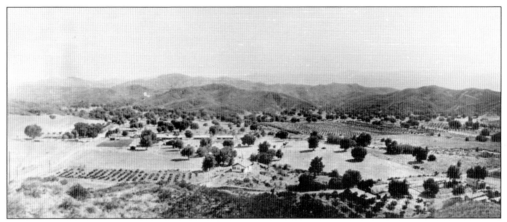

HAPPY VALLEY, C. 1920. The story goes that this section of Newhall was named after a local girl who lived in the area before it was built up. Her friends called it Happy's Valley, and the name stuck. While the name changed only slightly, the landscape changed significantly to a popular neighborhood where the roads were laid out to accommodate the ancient oak trees.

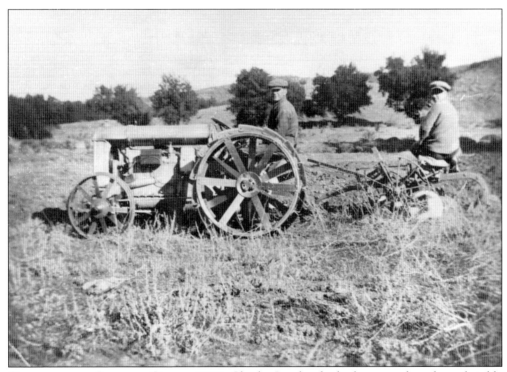

CULTIVATING IN LURCHER GROVE, 1920. Charles Lurcher had a large ranch and comfortable home located behind the junction of today's Maple and Valley Streets. Illustrated here is part of the never-ending work required to make a living at farming in Newhall's arid climate.

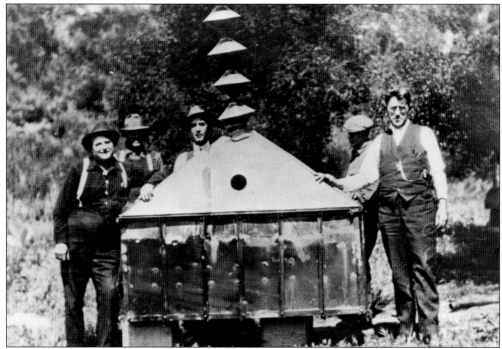

Bootlegger's Still, 1924. A town that started out with four bars and no church, Newhall did not embrace Prohibition, in spite of the earnest efforts of men like H. C. Needham and Alexander Mentry. Here Constable Jack Pilcher (left) and Federal Alcohol Tobacco and Firearms agent James Bond (right), as well as other members of Newhall Dry Squad pose with a confiscated still.

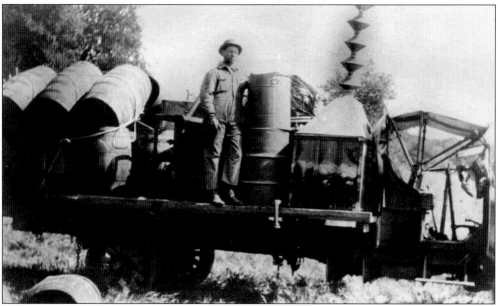

Transporting Bootlegger's Still. Finding the still was only part of the job; local bootleggers tended to think big, and their stills were massive. On one hand, it meant that the evidence tended to stay put; on the other hand, it had to be loaded once found. One local gang got creative by mounting their still on a flatbed truck and taking it with them when the dry squad was in the area.

THE BIG SNOW OF 1930. Newhall's location and climate does not lend itself to snowfall, much less heavy snowstorms, but once in a while Mother Nature surprises the town. So much snow fell in 1930 that it became known as "the big snow." Even with all the problems the snow caused, townsfolk found time to play.

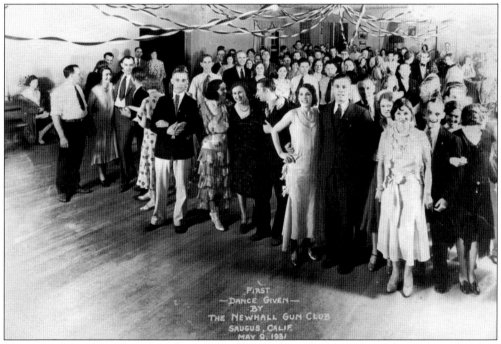

NEWHALL GUN CLUB DANCE. The people of Newhall worked hard to make a living, but they always were willing to make time for a good party. Here are the bright young things of Newhall and the surrounding area gathered at the first dance given by the Newhall Gun Club on May 9, 1931. Interestingly, the dance was held in Saugus.

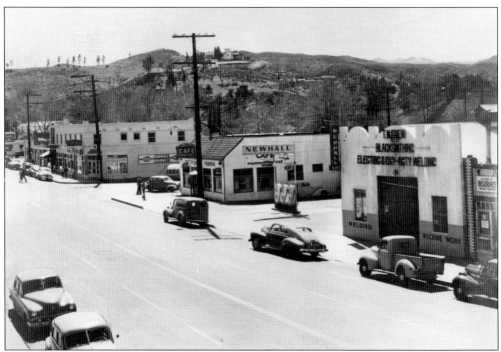

SPRUCE STREET PANORAMA, WEST SIDE. This is a view of Spruce Street (later San Fernando Road, now Main Street) in 1948. Easily seen from right to left are the Frew Blacksmith Shop, the Newhall Café, and the Newhall Pharmacy in the Swall building. William S. Hart's mansion is visible on the hilltop above the town.

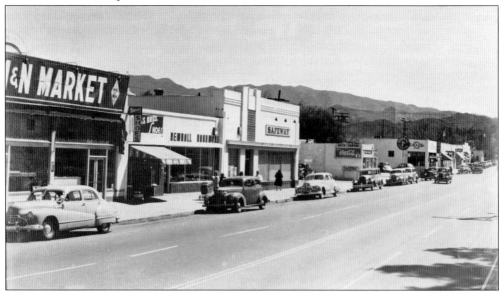

SPRUCE STREET PANORAMA, EAST SIDE. Here is the other side of Spruce Street in 1948. From left to right are M&N Market, a shoe store, Newhall Hardware, Safeway, and a gasoline station. Continuing across Market Street, the 5-10-25 store was on the site of the second Southern Hotel. Spruce Street was first paved in 1936 to facilitate travel to Highway 99/the Ridge Route alternative, which opened in 1933.

Seven

Just Passing Through

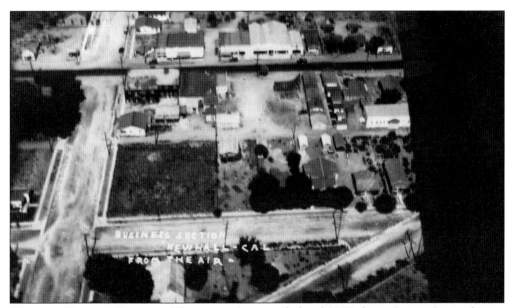

Newhall Business District. This unusual postcard, dated 1927, shows Spruce Street about a decade before the road was widened and paved. Doty's Garage is the large, white structure, and the Swall building can be seen on the corner of Spruce and Market Streets. The Pardee house is seen on the bottom of the picture, bounded by the triangle formed by Market Street, Walnut Street, and Newhall Avenue.

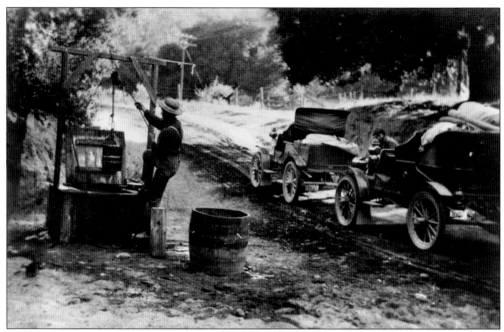

A Trip over Beale's Cut. Beale's Cut was the gateway to Newhall from the south for decades, and it was well traveled in spite of the dramatic incline that challenged horses and drivers alike. When the automobile age began, the road to the cut was improved once more, easing passage for the often-cantankerous machines. Even so, the trip required special preparations, as seen in the next four photographs. First, the traveler needed to be certain that his automobile had enough water to keep the soon-to-be overworked engine from overheating. Even with adding water, engines often overheated and caused the automobile to stop abruptly. Another common problem was the steep incline, preventing gasoline from flowing properly, again causing an abrupt stop. Waiting awhile for the engine to cool down and adding fresh water occasionally worked.

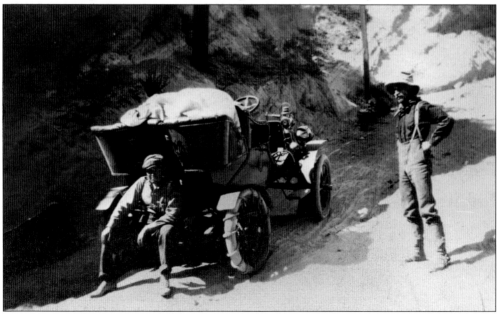

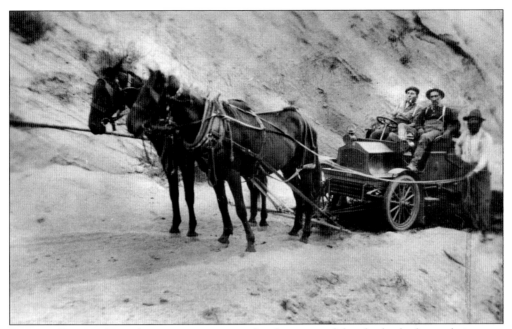

BACK TO BASICS. Once the engine gave up under the rigors of the climb, the best solution was often to convert the horseless carriage back to a horse-drawn one for the duration. There were usually a few teams conveniently nearby to provide this service—for a fee, of course.

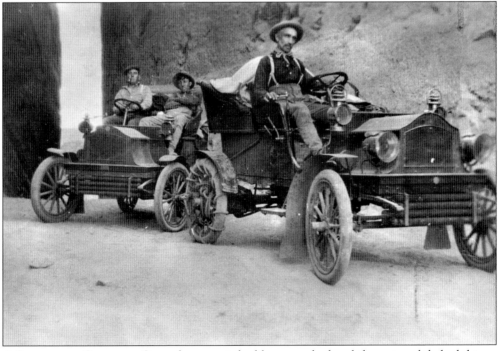

A SUCCESSFUL CROSSING. Once the summit had been reached and the automobile had driven through the cut, a pause was in order to rest, regroup, and prepare for the equally steep but much less demanding drive down the hill. Savvy drivers soon began to buy automobiles only after it was proven that they could make it over Beale's Cut unaided.

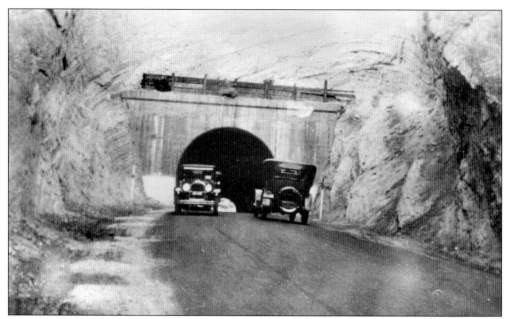

THE NEWHALL TUNNEL. The tunnel opened in 1910, bypassing Beale's Cut, with hopes of easing traffic flow over the mountains. As seen in the photograph, the tunnel had two narrow lanes and a curved ceiling, meaning that trucks were forced to drive in the center of the tunnel. Even so, they frequently scraped the sides or actually got stuck, stopping traffic in both directions until the truck could be freed.

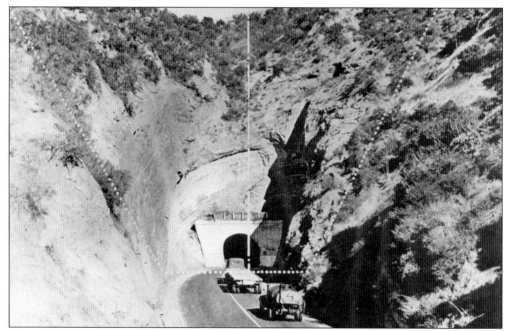

OPENING NEWHALL TUNNEL. The tunnel quickly proved to be incapable of handling the increasing traffic, and a bypass road was built. It too proved inadequate, and in 1938, the State of California decided to open the tunnel to the sky and widen the road. Shown here are the proposed lines of the excavation to open the tunnel. The vertical line is 200 feet long.

HIGHWAY 6. Once the tunnel was a highway open to the sky, travelers enjoyed a smooth, wide road, allowing speed and ease of travel that the early pioneers would never have dreamed of. Beale's Cut remained parallel to the road (today's Sierra Highway) but began to be forgotten. Even Hollywood came calling less often, and the once-vital pass slipped into obscurity.

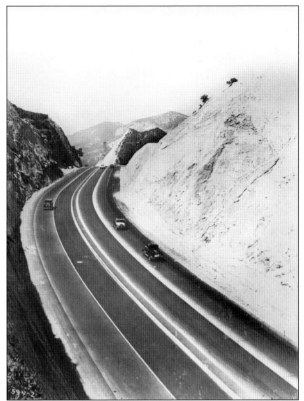

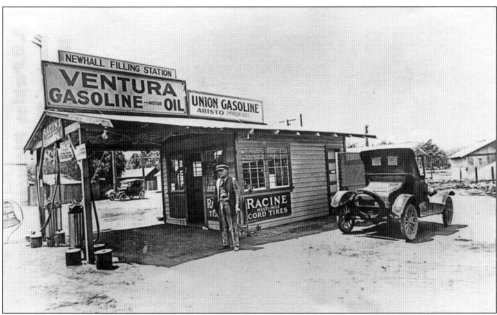

NEWHALL FILLING STATION. Newhall's first dedicated gasoline station opened on the corner of Eighth and Spruce Streets in 1916, serving locals and brave travelers on their way to or from the Ridge Route. Before the advent of gasoline stations, motorists bought their fuel from garages. Much of the gasoline sold was produced by local refineries.

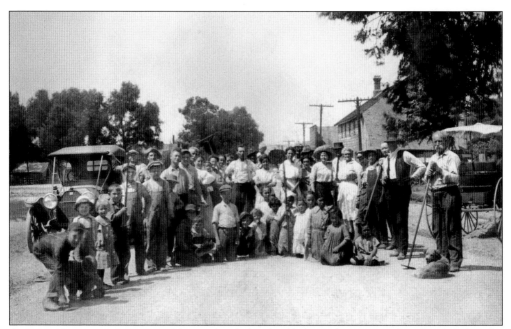

CLEANUP DAY, 1910. Once California decided to build the Ridge Route, they decided that the road leading to it should be as straight as possible. Frances Philips refused to sell her Railroad Avenue property, so the merchants of Spruce Street persuaded the planners to move the highway one block. Most of the town turned out to make certain Spruce Street was ready for its debut as a state highway.

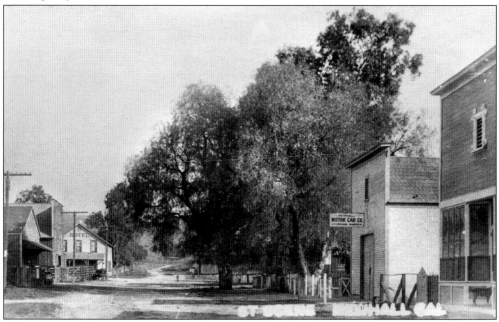

HIGHWAY IN 1912. This photograph of Spruce Street (not yet renamed San Fernando Road) shows how rural Newhall remained. On the right are the More house, Pardee's livery stables, and the second Southern Hotel, with native grass beyond. On the left is Woodard's soda fountain and Dutch Graham's garage, with the Frew Blacksmith Shop and home obscured by the trees.

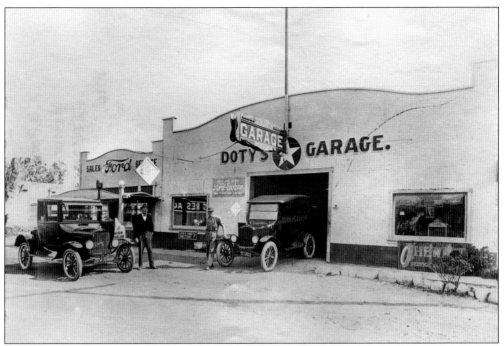

DOTY'S FORD GARAGE. Seeing the trend moving away from Railroad Avenue and its higher rents, Jesse Doty opened his garage on Spruce Street in 1914 and went off to war soon after. Known as White's Garage during World War I, he returned to his business after the war and became a fixture in Newhall for many years.

INTERIOR OF DOTY'S GARAGE. Taken sometime between 1916 and 1920, this photograph shows how important the automobile had become. Doty's may have had an unfair advantage in attracting customers due to his attendants all being pretty young ladies who drew gasoline into cans for customers—for the outrageous price of 10¢ a gallon!

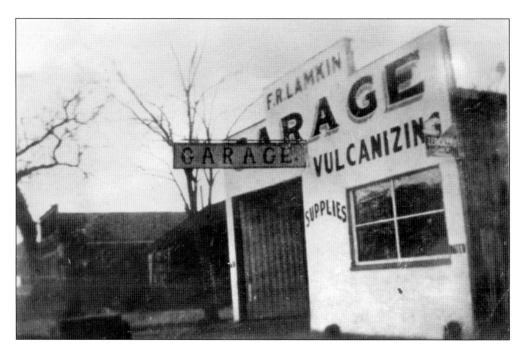

LAMKIN'S CHEVROLET GARAGE. Realizing that Newhall's location meant it could support more than one garage on Spruce Street, Fred Lamkin opened his Newhall Garage soon after he and his family arrived in 1917. The business thrived, and he soon allied himself with Chevrolet and evolved into a dealership. The friendly rivalry between Doty's Ford and Lamkin's Chevrolet lasted into the 1970s (under different owners by then) when both dealerships relocated to the new Valencia Auto Center. Both are still in business, but the rivalry has largely faded, as both are owned by the same company. The photograph below was taken in 1941, shortly after the United States declared war on Japan.

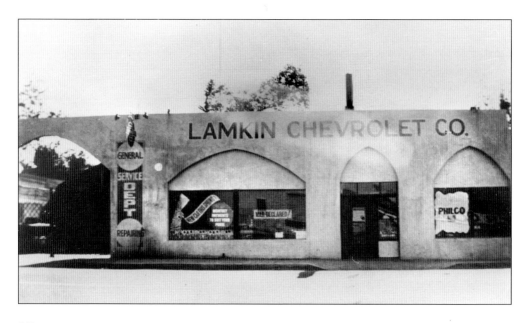

CHAIX VULCANIZING SHOP.
Emile Chaix, owner of the
Derrick Saloon and Chaix store,
also operated this vulcanizing
shop on Spruce Street, proudly
offering Firestone tires should he
not be able to repair a traveler's
damaged tire or inner tube. He
is seen here in the early 1920s,
apparently waiting for the next
stranded traveler to appear.

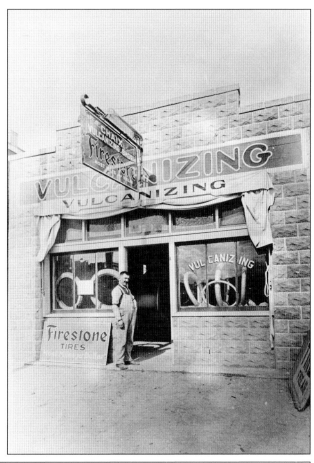

**FLOAT IN FOURTH OF JULY
PARADE.** Following the
long tradition of not taking
themselves or the local economy
too seriously, this 1934 parade
entry gently poked fun at both
the growing importance of
catering to automobile travelers
in Newhall and the frequent
mishaps that befell them.

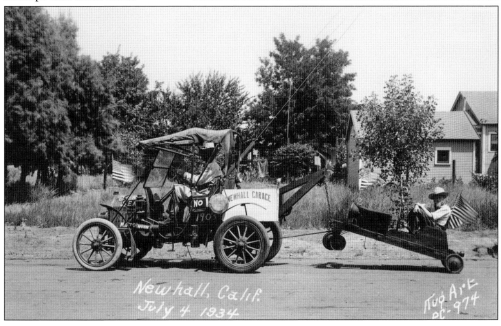

RUSSELL'S CAFÉ. Equally as important to the traveler as gasoline stations and garages, Newhall soon sprouted several cafés aimed at the motoring audience. Conveniently located on Spruce Street, they vied with each other for business. Russell's Café had a distinct advantage in being right next to Doty's Garage.

MOTOR STAGE CAFÉ. The Motor Stage Café was a popular hangout for locals and travelers. It was built on the corner of Spruce and Market Streets in 1926 after the Frew home was sold and moved to Thirteenth Street. It stayed in business for more than 30 years until the building was razed in 1958 to make room for the Sprouse-Reitz store.

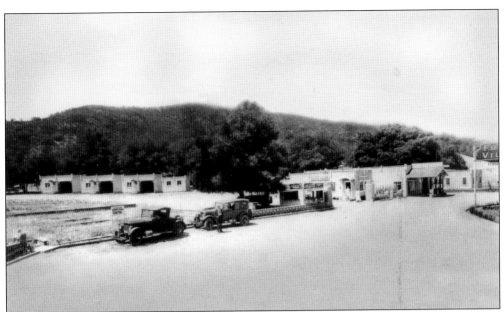

FRENCH VILLAGE AUTO CAMP. The south side of Newhall's outskirts became a popular spot for automobile camps. The French Village was built in 1926 by a Mr. Courtmanche and featured a store, a garage, and 10 cottages with covered parking. The above photograph shows the camp looking tidy and inviting, with a semicircle driveway that made getting off and on the road easy for the weary driver. Like most of the businesses catering to travelers on San Fernando Road, the French Village flourished and was soon able to add a restaurant and expanded accommodations. The sign in the picture below reflects that expansion, emphasizing the food served. The undated photograph was shot the night the gasoline station burned down, possibly taking more buildings with it.

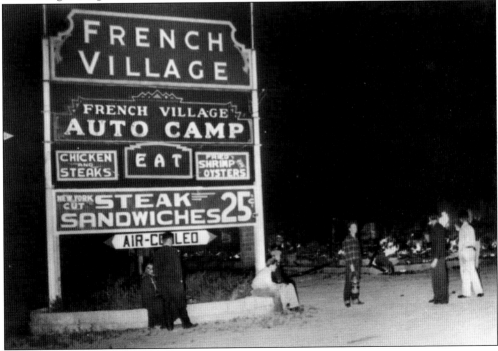

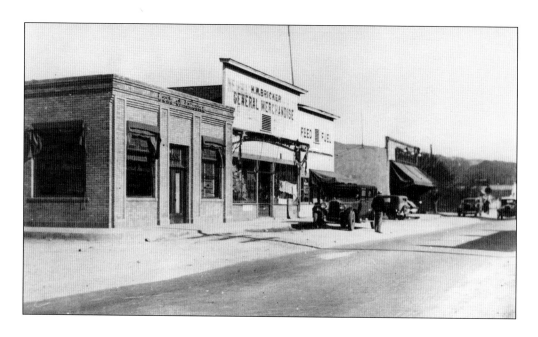

SAN FERNANDO ROAD BEFORE AND AFTER PAVING. By the early 1930s, it was obvious that Newhall was in danger of being bypassed into quiet oblivion. Highway 99 (today's Interstate 5) was open on the west side of town, and Highway 14 was soon to be built on the east side. Spruce Street was still a designated highway, but it was a 60-foot-wide dirt track with oil streaks and old buildings. The Kiwanis Club went into action, obtaining state and county funding to widen and pave the road. All but two property owners agreed to donate 20 feet of frontage to the state in order to get the job done. The county paid the holdouts, and the buildings were either moved back or cut off as needed. Several months later, the other property owners were surprised to receive small payments for the footage donated.

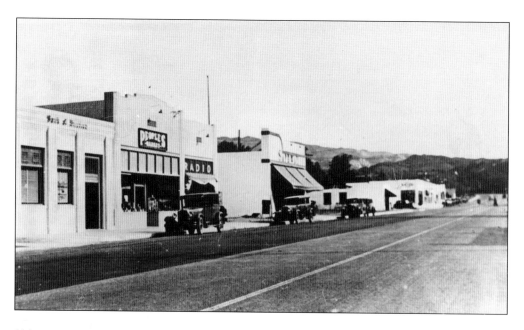

Eight

THEN AND NOW

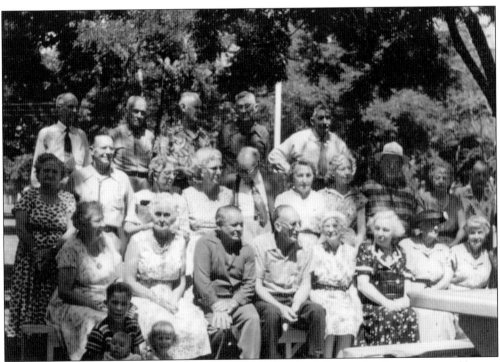

NEWHALL PIONEERS, 1958. Newhall, like any town, was built by people who constructed homes and businesses, raised crops and livestock, went to church on Sunday, and raised a little hell the rest of the week. Without the determination of these people, the town would have died with Henry Mayo Newhall in 1882. When this picture was taken, many of the old families had gone, but their legacies remain.

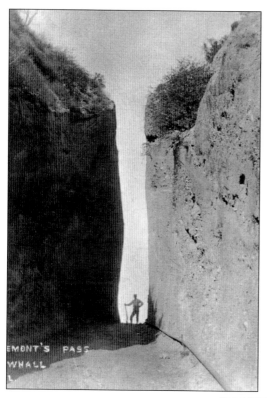

BEALE'S CUT. This postcard dates from about 1910, long after Beale's Cut's heyday and at the end of its service as an automobile route. Nearly 50 years old, the walls were still vertical and clean, and the dramatic impact of Edward F. Beale's achievement remained impressive. But time and neglect have blunted the drama. Storms have caused minor landslides that have filled the cut to around the level Phineas Banning made, about 30 feet deep. One wall is still in good condition, and the tool marks can still be seen where the workers dug away the mountain. Now private property, the City of Santa Clarita is studying ways to restore the cut to its former depth and open it to the public. Beale's Cut is a registered state historical landmark.

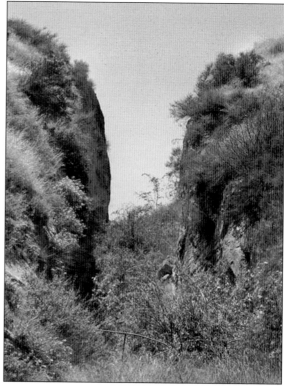

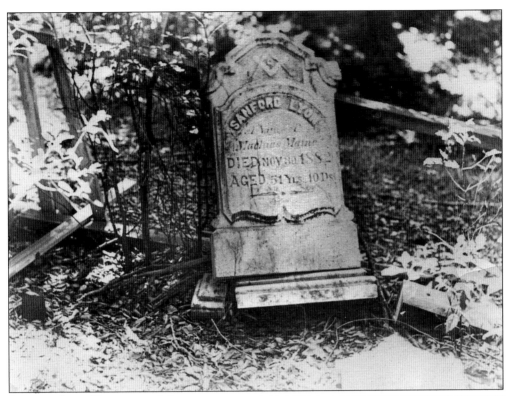

SANFORD LYON TOMBSTONE. Like most frontier towns, Newhall did not have a central cemetery in its earliest days. For those who did not have the land for a family plot, a cemetery evolved at Lyon Station. Even after the stage station was closed, the cemetery continued to be used. In the 1950s, the Needham family sold their ranch, including the cemetery. A new cemetery called Eternal Valley was laid out with room to grow. That meant the graves had to be moved. The oldest graves, including that of Sanford Lyon, were put close to the entrance in the Garden of Pioneers. The above photograph was taken in Lyon's Station Cemetery shortly before the graveyard was moved. The photograph to the right shows the grave as it appears today, repaired and in a serene, open setting.

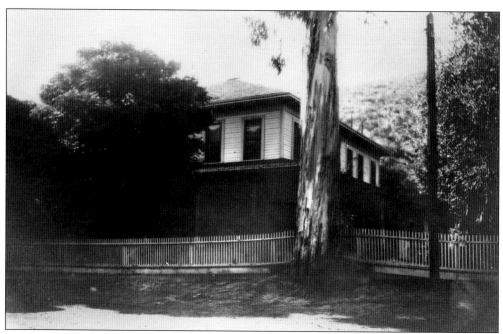

ALEXANDER MENTRY'S HOME, MENTRYVILLE. Built by Alexander Mentry, this 13-room house was sometimes known as the "big house" or the "manse," acknowledging its size and attractive appearance. Although much of Mentryville has fallen victim to salvage and fire, the manse survived and has been restored to its former glory, one of a handful of buildings in Mentryville that still exist. Chevron donated Mentryville to the Santa Monica Mountains Conservancy in 1995, and it is now a park of sorts. The buildings are not open to the public, and access to the center of town is by appointment only. Still, anyone can drive into Pico Canyon and to Mentryville and walk around the perimeter, looking at the buildings still in their original setting. Mentryville is a registered state and national historic landmark, along with California Star Oil Well No. 4, the oil well that started it all.

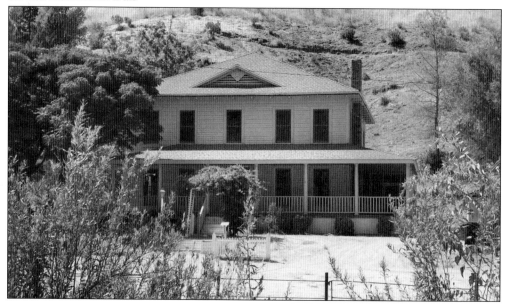

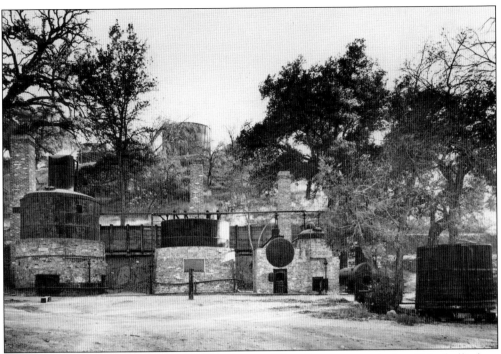

PIONEER OIL REFINERY. The Pioneer Oil Refinery off Pine Street is a reminder of Newhall's deep reliance on oil in the early days of the town. Oil is still being pumped in the valley, although the Newhall Refinery has followed the Pioneer into rusting retirement. Declared a state historic landmark in the 1930s, the above picture was taken soon after the refinery's dedication and a refurbishment by Standard Oil to mark the occasion. Now largely forgotten, even the graffiti is faded and parts of the refinery are beginning to show signs of collapse. The gate is kept locked, but it is possible to walk around the perimeter even though all the signage is long gone. The City of Santa Clarita is studying ways to restore the refinery and open it to the public once more.

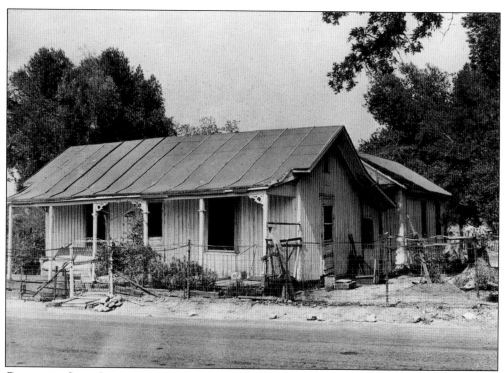

CALIFORNIA STAR OIL HOUSE. Built in March 1878 near the Pioneer Oil Refinery, the one-time VIP guesthouse was used as an office before being sold in 1915 to longtime employee Josh Wooldridge, who had been renting it from the company. He lived in the house until his death in 1950. One of the oldest houses in Newhall, the structure has been well maintained with minimal exterior modifications over the years. It is listed as a historic property by the City of Santa Clarita and should continue to be an active residence for many more years. It is a largely overlooked survival of the earliest days of the town of Newhall and the infancy of California's oil industry. (Below, courtesy of SCVHS.)

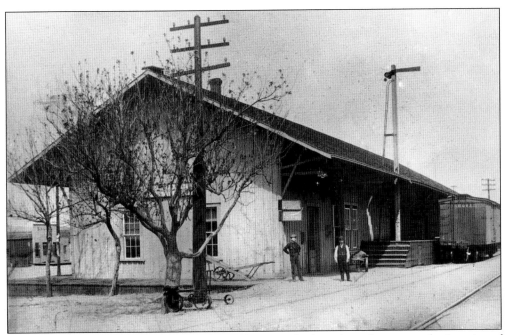

NEWHALL TRAIN STATION. The original train depot was built at about the present-day junction of Bouquet Canyon and San Fernando Roads in 1876 and was moved along with the rest of the town in 1878 to be closer to a reliable water source. Passenger service to Newhall ceased in 1933, and the depot was repurposed, first as a vegetable packing plant and then as storage. It burned down in 1962, probably as a result of hobos camping inside. In 2000, the new Metrolink train station was built at the same location, meaning that once again railroad trains stop on Railroad Avenue.

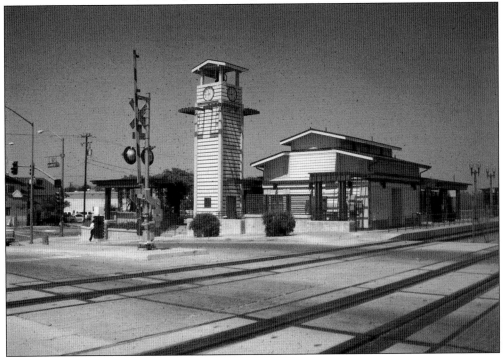

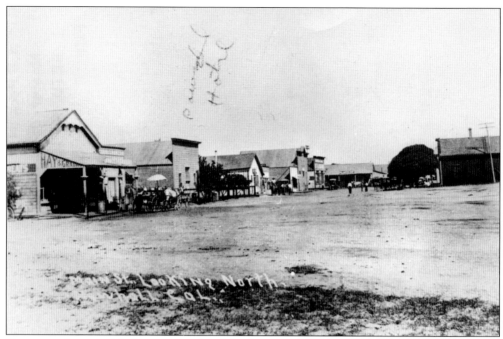

RAILROAD AVENUE. No longer considered the business center of town, Railroad Avenue today has become the main road for getting through Newhall while on the way to somewhere else. The jogs in the road have been smoothed out over the years as widening occurred, but the curve of the road at the north end around the former Delano complex still survives. Not much else survives from the old days besides the old Masonic club building across from the station. Where there were once homes and businesses, now there are mostly parking lots and back doors, as businesses keep their faces turned toward Main Street.

MASONIC CLUB BUILDING. Built in 1931, old-timers still refer to it as the old courthouse. Little changed over the years, it is one of the few buildings on Railroad Avenue that has a business front facing the street. The relatively new Railroad Café is housed in an addition to the original building. Other small businesses are also in the building, which dominates the northwest corner of Market Street and Railroad Avenue, as it has for more than 75 years. In an interesting survival, the upstairs floor is made of reused floorboards from the old Hap-A-Land, providing a tangible link even today to the terrible aftermath of the St. Francis Dam disaster. (Above, courtesy of SCVHS.)

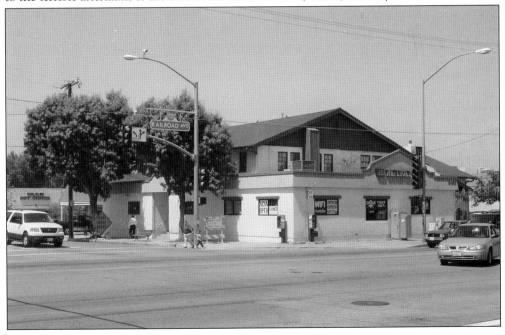

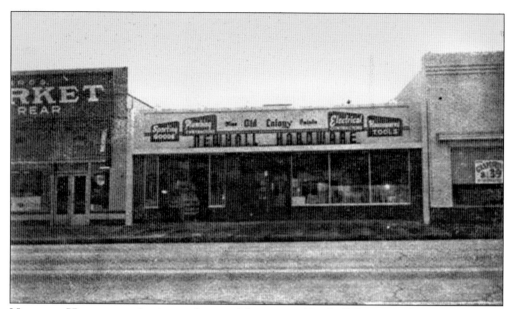

NEWHALL HARDWARE. An integral part of downtown Newhall for more than 60 years, the store recently closed due to economic pressures. It was an old-fashioned hardware store of the best kind, seemingly with anything and everything a customer could want to be found on the shelves, in barrels, or even hanging from the ceiling. The barrel of peanuts for customers (and browsers) always delighted children and more than a few adults. Times change, the needs of a town change, and, like Campton's Store and many other places everyone thought would last forever, the Newhall Hardware store has stepped into history as a fond memory for many. (Both, courtesy of SCVHS.)

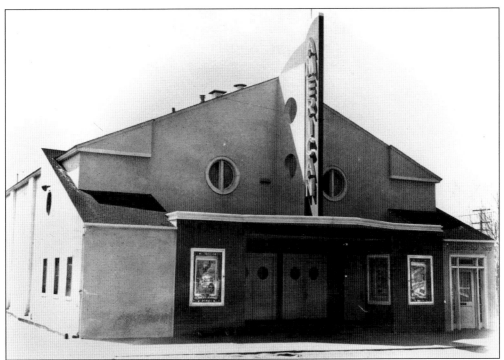

AMERICAN THEATER. William S. Hart decided in 1940 that Newhall should have a movie theater of its own, so he contacted the local American Legion and offered to donate the land and money needed for such a project. Needless to say, they agreed, and the theater opened in 1941. The opening movie was *Tumbling Tumbleweeds*, starring Gene Autry, fulfilling Hart's request that they show a Western at least once every week. The theater stayed open until 1965, by which time it was colloquially known as the "sit and scratch" due to a flea infestation. The American Legion turned it into their meeting and social center, and it continues to fill that role today. (Below, courtesy of SCVHS.)

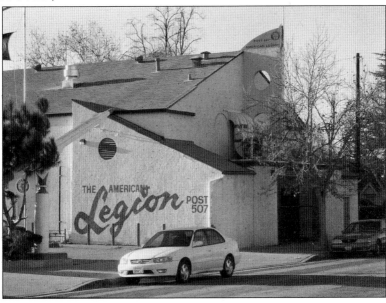

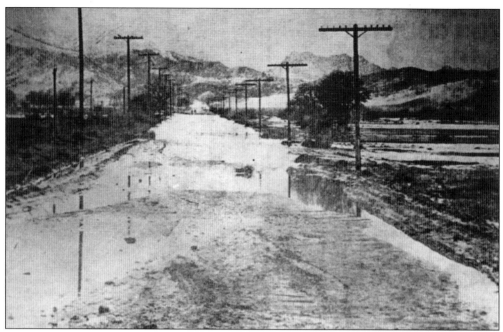

LYONS AVENUE. Lyons Avenue is a street named by two mistakes. The first mistake is that Sanford Lyon had anything memorable to do with the street. The second is a matter of usage; it was meant to be Lyon Avenue, but people found it easier to say Lyons. Originally it was called Pico Road, as it ran from Railroad Avenue all the way out to Pico Canyon. Seeing this photograph from 1941, the perception of Mentryville as a far away place begins to make sense. These pictures were taken from about the same spot in the middle of the intersection of Lyons and Peachland Avenues looking toward Pico Canyon. The mountains and some of the trees may be the same, but that is about it. (Above, courtesy of SCVHS.)

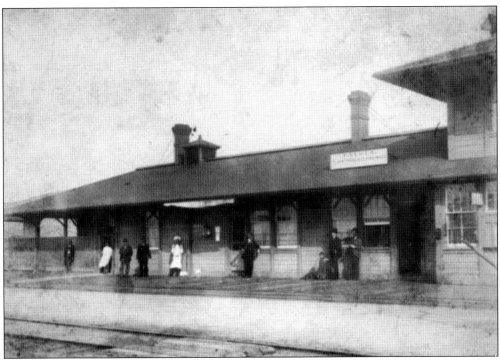

SAUGUS TRAIN STATION. The Saugus train station was dedicated in 1887 and was built to serve a spur line to the coast that eventually ran all the way to San Francisco. The building was completed in early 1888, and the station went into full service. Its location on the spur kept it open until 1978, forty-five years longer than the Newhall train station. To save the building from demolition, a massive fund-raising campaign was launched, and in 1980, the Saugus station was moved to its new home—Newhall. Today it sits by the tracks and is the headquarters of the Santa Clarita Valley Historical Society and the centerpiece of Heritage Junction Historic Park. (Courtesy of SCVHS.)

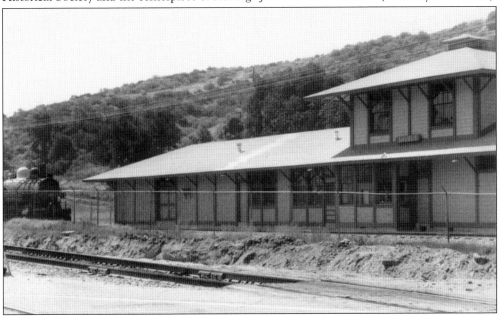

www.arcadiapublishing.com

Discover books about the town where you grew up, the cities where your friends and families live, the town where your parents met, or even that retirement spot you've been dreaming about. Our Web site provides history lovers with exclusive deals, advanced notification about new titles, e-mail alerts of author events, and much more.

MADE IN THE **USA**

Arcadia Publishing, the leading local history publisher in the United States, is committed to making history accessible and meaningful through publishing books that celebrate and preserve the heritage of America's people and places. Consistent with our mission to preserve history on a local level, this book was printed in South Carolina on American-made paper and manufactured entirely in the United States.

This book carries the accredited Forest Stewardship Council (FSC) label and is printed on 100 percent FSC-certified paper. Products carrying the FSC label are independently certified to assure consumers that they come from forests that are managed to meet the social, economic, and ecological needs of present and future generations.

FSC

Mixed Sources
Product group from well-managed forests and other controlled sources

Cert no. SW-COC-001530
www.fsc.org
© 1996 Forest Stewardship Council

Find Your Place in History.